IMAGES
of America

PULASKI AND THE
TOWN OF RICHLAND

Lawrence Petry

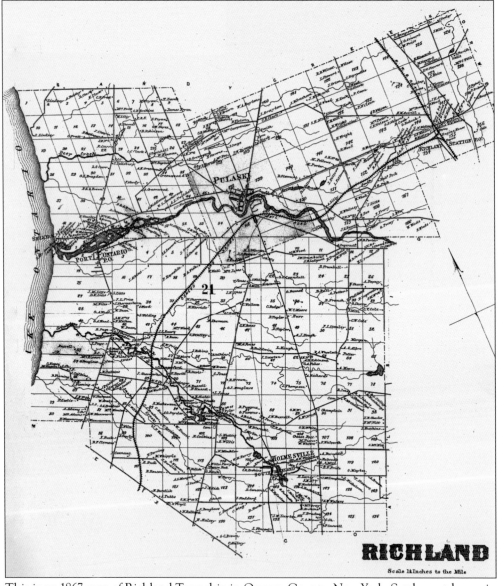

RICHLAND

Scale 1¼Inches to the Mile

This is an 1867 map of Richland Township in Oswego County, New York. Settlement began in 1801, and the town was established on February 20, 1807. The western border of the town is Lake Ontario, to the south is the town of Mexico, to the north is the town of Sandy Creek, and on the east are the towns of Albion and Orwell. (Courtesy of the Pulaski Historical Society.)

ON THE COVER: Benjamin Snow Sr. and investor William Greenwood founded the Eagle Foundry in Pulaski in 1832. It became the Ontario Iron Works when Arthur Olmstead purchased the company in 1892. Here, the employees pose for a photograph in 1902 in front of the new two-story, brick building constructed in 1901. They are, from left to right, (seated) F.J. Weeks, foreman Herman S. Killam, proprietor Arthur E. Olmstead, Supt. Benjamin Snow, Henry Filkins, and Frank P. Hardy; (standing) Claude L. Bonney, George E. Buck, Frank A. Prouty, C.A. Sackett, Lyman Mallory, Frank Brundage, Frank E. Gurley, Clarence Kelsey, and G.E. Wallace. (Courtesy of the Pulaski Historical Society.)

IMAGES
of America

PULASKI AND THE
TOWN OF RICHLAND

Lawrence Petry and the
Pulaski Historical Society

ARCADIA
PUBLISHING

Published by Arcadia Publishing
Charleston, South Carolina

Printed in the United States of America

Library of Congress Control Number: 2014932583

For all general information, please contact Arcadia Publishing:
Telephone 843-853-2070
Fax 843-853-0044
E-mail sales@arcadiapublishing.com
For customer service and orders:
Toll-Free 1-888-313-2665

Visit us on the Internet at www.arcadiapublishing.com

In memory of Mary Ellen Touhey Hallingby Siemers and Iris Hallingby Petry, two women whose love of this area of "God's Country" lives on

CONTENTS

Acknowledgments 6

Introduction 7

1. Getting Down to Business 9

2. No Place Like Home 37

3. Port Ontario and Selkirk 49

4. All around Richland Town 65

5. We Gather Together 77

6. Early School Days 87

7. A River Runs Through 95

8. And Train Tracks, Too 115

9 Time to Celebrate 121

Bibliography 127

Acknowledgments

First, my thanks go to Mary J. Centro, author of the Arcadia Publishing book Images of America: *The Lost Village of Delta*. Her book, her enthusiasm for local history, and her advice started me on this adventure.

Thanks also to all those who have kept local history alive, first to the photographers of long ago like R.S. Avery, Charles D. Hadley, and Henry M. Beach, who documented everyday life, and then to those who collected and preserved those images of the past, along with historians like Mary Parker.

Next are the many postcard dealers who enabled me to start my own postcard collection, and the collectors who filled in some gaps. Of special note are dealers Frances Perth, Linda Manning, and Mary L. Martin and collectors Dick Gorski and Andy Gibbs.

I appreciate the resources available through the Pulaski Public Library, the Syracuse Central Library's Local History Collection, and, of course, the Pulaski Historical Society, with special thanks to president Terry Rossman, curator Mary Lou Morrow, JudyAnn Carney, and the rest of the talented crew of volunteers. Unless otherwise noted, all images appearing in this book are courtesy of the Pulaski Historical Society.

INTRODUCTION

Long before the first white settlers came to the eastern Lake Ontario area, Native American tribes occupied the land. The Five Nations, or Iroquois, joined together in a defensive alliance in the area west of the Hudson River. The Mohawks inhabited the easternmost part, followed by the Oneidas, the Onondagas, the Cayugas, and the Senecas on the western side. They were well established prior to the exploration of Henry Hudson in 1609.

The first European to enter the Oswego County area was French explorer Samuel de Champlain, in October 1615. He, along with 10 Frenchmen and Huron Indians from Canada, landed at the mouth of the Salmon River and traveled to the Onondaga Lake area and attacked a fortified Iroquois village. In a three-hour battle, Champlain was wounded twice by arrows, and he withdrew his forces back to Canada.

On August 1, 1655, a second Frenchman, Jesuit Father Simon LeMoyne landed at the mouth of the Salmon River by canoe from the St. Lawrence River on a goodwill mission call to the Onondaga Nation. His report included observations of fishing villages on both shores at the entrance of the river.

On July 10, 1684, the French governor-general of New France (Canada), M. Le Febvre de la Barre, led an expedition of 1,800 troops against the Senecas, who had attacked French allies, traders, and a fort, as well as the Onondagas, who were taking their fur trade to the English. At a council held at the mouth of the Salmon River on September 5 and 6, 1684, Garangula, or "Big Mouth," an Onondaga chieftain and orator, told de la Barre that he and his troops, weakened by sickness, were at the mercy of the Indian forces. De la Barre made a quick treaty and a hasty retreat back to New France.

Preceding the Revolutionary War, the only existing military outposts beyond Fort Stanwix, in Rome, New York, were the remote forts located at Niagara and Oswego. These forts were only occupied in times of crisis. A major population center did not exist beyond the Mohawk River and Albany.

In 1788, the Iroquois Nations ceded most of their lands to the State of New York in the Treaty of Fort Stanwix. In 1793, land speculators John and Nicholas Roosevelt, ancestors of two future US presidents, bought a large tract of land from the State of New York.

Following the Revolutionary War, Oswego was one of the last outposts occupied and fortified by the British. Once it was vacated around 1796, land speculators purchased acreage sight unseen. One of these speculators, from New York City, was a man named George Scriba. He and some partners bought about 500,000 acres in 1794. He hired Benjamin Wright of Rome to have the area mapped. One of the 22 assistants who did this was Benjamin Winch, who surveyed the area of the towns of Richland and Sandy Creek. He set up a base line from Fort Ontario, in Oswego to Fort Stanwix, in Rome, and divided the Scriba Patent into 24 towns. Winch found the land so promising that he himself purchased acreage, on which the present-day village of Pulaski stands. He built the first cabin, made of logs, which provided warmth and comfort to early travelers.

Agents were sent throughout New England and Pennsylvania promoting the availability of these rich lands in upstate New York. Thus the township gained the name Richland. The earliest settlers traveled the route following the Mohawk River Valley. They then followed adjoining waterways, military roads, or Indian trails until they came to the lands suitable to their desires.

Nathan Tuttle of Canada and Nathan Wilcox and Albert Bohannan of Rome made the first settlements in 1801, near the mouth of the Salmon River.

The first settlers of Pulaski came from Pawlet, Vermont, arriving on March 22, 1805. A number of these founders were direct descendants of the Pilgrims who came to the new world on the *Mayflower*. Ephraim Brewster traced his ancestry to William Brewster, and John and Simon Meacham descended from Capt. Miles Standish. They were attracted here by the rich soil for farming, the dense woodlands for lumber, the abundance of game, and, mostly, the river. The abundance of fish, an important source of food, gave the village of Pulaski its first name, Fishville. The river made travel easier, made trade with Oswego better, and was a source of power for early mills.

The Town of Richland was formed from Williamstown as part of Oneida County on February 20, 1807. Orwell was removed from it in 1817, followed by Albion and Sandy Creek in 1825, a part of Mexico in 1836, and another part of Orwell in 1844. The Village of Pulaski was incorporated on April 26, 1832.

The origin of Pulaski's name comes from stories passed down through the generations. In 1807, the village men gathered in a local tavern and debated on changing the name from Fishville. They placed a number of notable names like Jefferson, Franklin, Clinton, and others into a hat. The name drawn was Casimir Pulaski, a Revolutionary War hero. Not knowing the correct pronunciation of Pulaski (pul-as-KEY), they interpreted the name as "pul-as-SKY," and this colloquial interpretation has remained.

Casimir Pulaski came from Poland to America on July 23, 1777, to help in the battle for independence. The Continental Congress appointed Pulaski brigadier general of cavalry on September 15, 1777. He was wounded in the Battle of Savannah and died two days later on October 11, 1779. He was 32 years old.

In the spring of 1805, Jesseniah Holmes and his oldest son, John, visited this area from Pomfert, Connecticut, and, in 1807, they settled near Grindstone Creek, on the southern end of the town, where they found the resources to start a thriving community. Lodwick Willis and his family were early settlers in Holmesville. They owned a large home that became a stopping place for stagecoaches, and passengers could stay overnight in one of the 15 upstairs bedrooms. Capt. Robert Muzzy Sr., a Revolutionary War veteran, was an early settler. Charles Louis Goodsell came to Holmesville in 1885. In 1897, the family built a three-story, wood-framed mill on the banks of Grindstone Creek. The Goodsell Mill, now called the Fernwood Feed Mill, served as a gristmill, a feed store, a sawmill, and a cabinet shop. The hamlet changed its name to Fernwood in 1899 when it was learned that there was another post office in New York named Holmesville.

About 1836, a group of promoters, John L. and Asa C. Dickinson, Elias Camp, and Col. Robert Nichols, came up with the idea of building a city at the mouth of the Salmon River. Their contemplated city was surveyed and plotted into 125 half-acre lots and 66 five-acre lots. On April 10, 1837, the Port Ontario Hydraulic Company was incorporated to construct "a canal from the falls below Pulaski to the Village of Port Ontario along the banks of the Salmon River." As a result, land values skyrocketed overnight, and building lots sold at exorbitant prices. Historian Chrisfield Johnson wrote, "The embryo city was announced with a great flourish of trumpets and its progenitors felt that it would outstrip Oswego." The village was incorporated on April 24, 1837, and in May, the state legislature chartered the Salmon River Harbor Canal Company to construct a canal from the lake at Selkirk to the village of Port Ontario. Efforts to develop Port Ontario fell through following the financial crash of 1837. However, a government lighthouse was built at Selkirk in 1838 that was in active service until 1858.

Selkirk was probably named for Thomas Douglas, Earl of Selkirk, a Scots nobleman who owned nearly 4,400 acres of land on the north side of the Salmon River. Henrietta M. Coulden of New York City purchased a three-mile-square portion of the Scriba Patent for him on November 16, 1796. Later, the Brown family, descendants of Benjamin Winch, owned much of this acreage.

In 1850, the Rome & Watertown Railroad transformed the quiet hamlet of Richland into a busy railway junction, which it continued to be through the busy days of the railroads.

One

GETTING DOWN
TO BUSINESS

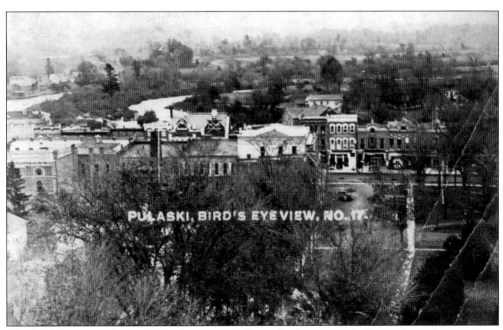

This bird's-eye view from 1907 looks west and shows the downtown Jefferson Street business area of the village of Pulaski. In the background is the Salmon River, which winds through the middle of the village for about two and a half miles.

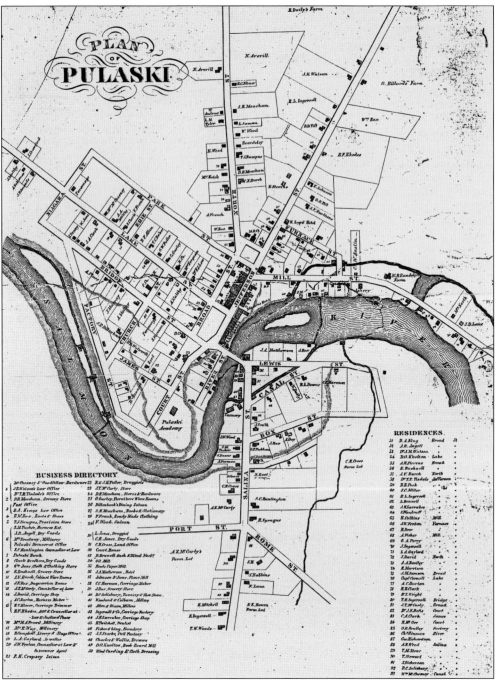

Pulaski was incorporated as a village on April 26, 1832. This map from 1856 lays out the locations of the businesses and homes of the day. The waterpower of the Salmon River was used for the mills and factories along its banks.

The Oswego County Courthouse was built in 1819 by James Weed on land donated by Benjamin Wright, the second justice of Oswego County. It was remodeled and enlarged in 1858–1859 by builder David Bennett and then renovated by architect F.B. Parker in 1887. Besides being used for trials, the courthouse was used as an early meeting place for many of the local church denominations, as well as for lectures, concerts, basketball games, school dances, class sessions, and graduation services. Pulaski shared the county seat title with Oswego City as the result of an 1840s compromise that kept the northern Oswego County towns from seceding to form a separate county; thus, Pulaski is a "half-shire" town in the old English tradition. In 1987, following the last renovation, the courthouse was named in honor of H. Douglas Barclay, a former state senator. The three-tiered fountain with a large fish standing on its tail was built in front of the courthouse in 1903. It was replaced in 1920 with the present Civil War monument.

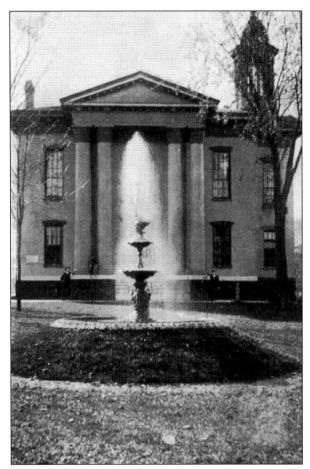

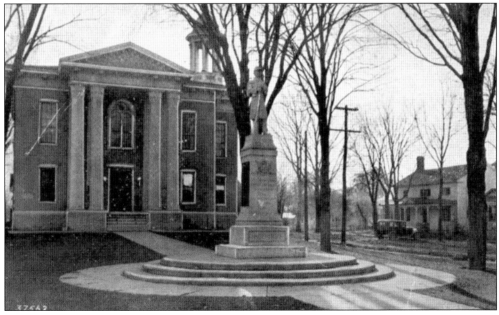

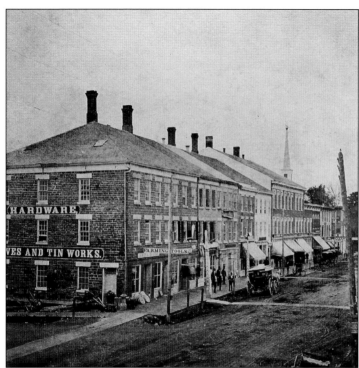

This 1879 view shows the west side of Jefferson Street looking north. The hardware store in the foreground had been run by Lyman and Beadle, followed by Alfred N. Beadle and then McChesney and Goodfellow. The stagecoach is in front of Tucker's Hall, a gathering place for lectures, shows, concerts, and dances. The steeple of the Methodist Episcopal church can be seen in the background.

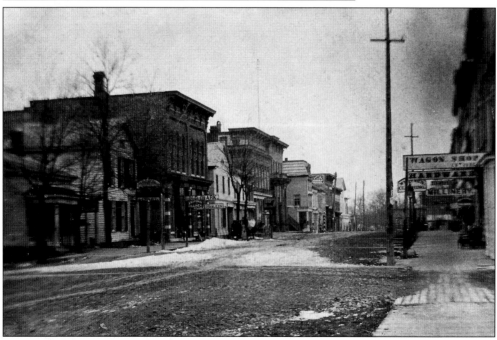

This view of Jefferson Street looks south from Mill and Park Streets prior to 1881. The C.H. Brooks store replaced the house on the left. The second building from the left belonged to Ed Forman, livery; followed by E.D. Forman, milliner; H.B. Clark, dry goods; and M.L. Hollis, crockery. On the right are Joseph David, wagon maker; A.N. Beadle, hardware; a millinery shop; and William June, clothing.

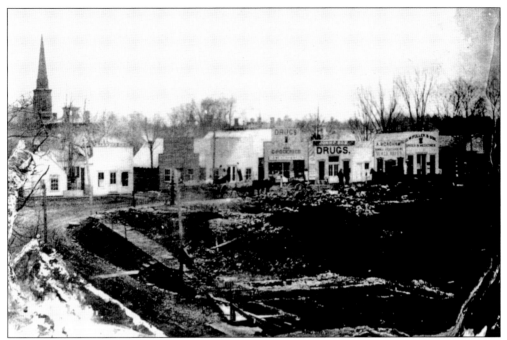

At 4:00 a.m. on October 6, 1881, a fire began in a bakery in the rear of Malcolm L. Hollis's store. Over three and a half hours, the devastating blaze destroyed at least 55 businesses (foreground), including the engine house of the Ringgold Fire Company. As seen here, merchants set up temporary wooden storefronts in South Park. The steeple of the Congregational church is on the left. (Courtesy of Lawrence Petry.)

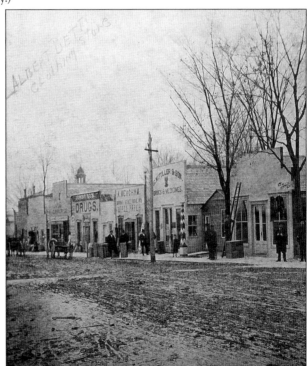

This view of the businesses that set up in South Park looks south, with the county courthouse cupola in the left background. On July 4, 1883, a bonfire was lit in the park to celebrate the removal of all the temporary buildings.

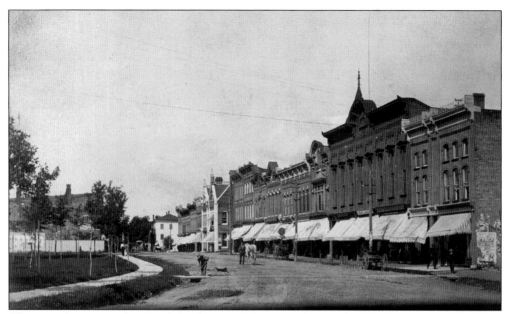

This view from around 1890 of the downtown business district shows the east side of Jefferson Street, looking north from the courthouse. South Park is on the left. The Pulaski National Bank building, outlined in white, is in the center of the image. (Courtesy of Lawrence Petry.)

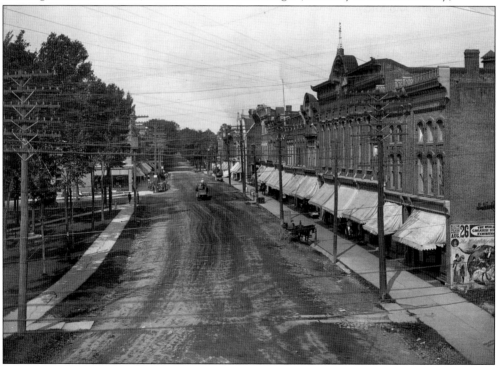

This later view of Jefferson Street shows the addition of telephone poles. Three telephone companies were given permits in the village in 1902. Many villagers were concerned that the poles were dangerous and unsightly; as early as 1912, there was a movement to remove them from the village streets. (Courtesy of Lawrence Petry.)

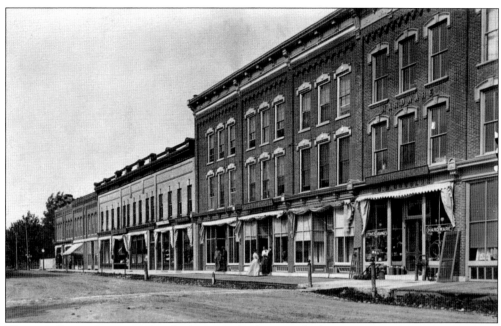

This is Jefferson Street in 1902 looking south, showing the businesses on the west side rebuilt after the 1881 fire. From right to left are G.W. Douglas Hardware, the Pulaski House, New York Millinery Store, and Michael Daly's.

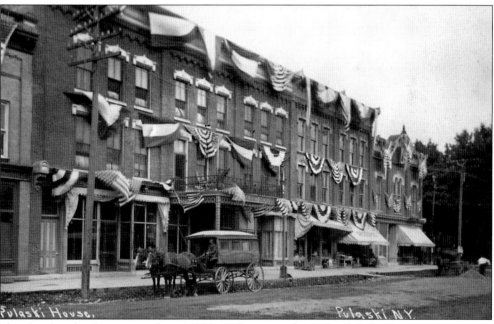

Shortly after the devastating fire of 1881, William June built the Pulaski House, a three-story, brick hotel on the west side of North Jefferson Street. John F. Hubbard bought the Pulaski House in 1903. Seen here in 1910, it was a popular spot for traveling salesmen as well as a residence for some local people. Fire destroyed it on October 6, 1960, during the first General Pulaski Days. A bank now occupies the site. (Courtesy of Dick Gorski.)

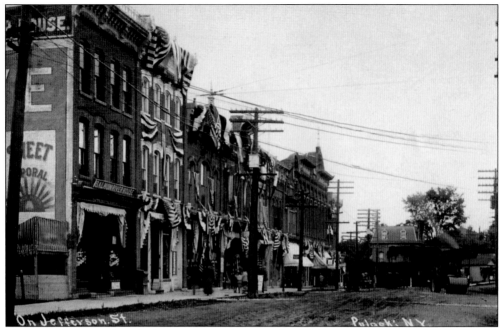

This view looks south at the businesses on the east side of Jefferson Street around 1909. On the left is the "new" Salmon River House. At the end of the street, to the left of the steamroller, is the J.L. Hutchens House (now known as the 1880 House), with the Cross Land Office, built in 1860, in front of it. (Courtesy of Dick Gorski.)

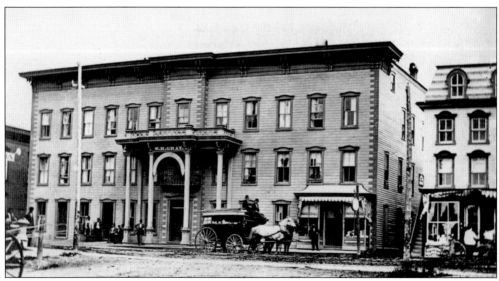

The old Salmon River House stood on the east side of Jefferson Street facing Lake Street. William H. Gray was the owner at the time this photograph was taken, around 1885. Notable guests included Rev. Edward Beecher, Gerritt Smith, Frederick Douglass in 1854 or 1855, and Horace Greeley and George Low of the *New York Tribune* in the early 1850s.

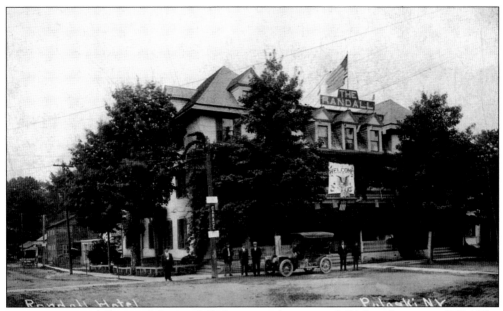

Benjamin D. Randall opened the Randall House, seen here around 1906, in the spring of 1894. The three-story hotel had steam heat, indoor bathrooms, and natural gas lighting, and it overlooked the Salmon River. Randall's wife operated a ladies' bazaar in the building. The hotel was built at the corner of Salt Road (now Salina Street) and Lewis Street on the site of the 1804 log cabin home and tavern of Pulaski's first permanent white settler, Benjamin Winch. Fire damaged the hotel in 1957. In 1962, following a fire that destroyed the upper story, the business was rebuilt as the Log Cabin Inn. That building was destroyed by fire in June 2000. The River House Restaurant now occupies the site.

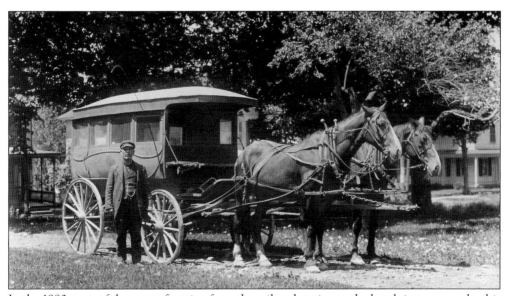

In the 1880s, one of the ways of getting from the railroad station to the hotels in town was by this early shuttle service. William "Scruffy" Andrews, pictured here in 1890, provided this carriage service, and he also transported mail from the railroad station to the post office for 32 years.

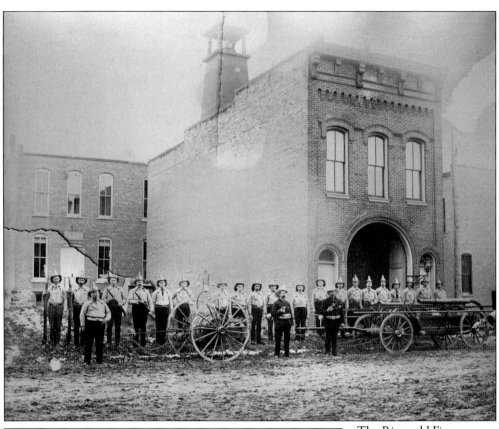

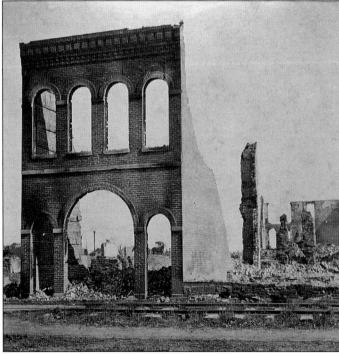

The Ringgold Fire Company was incorporated in 1873. Here, unidentified members of the company stand in front of the old firehouse, which opened on Thanksgiving Day in 1869, with a hose cart and a pumper that was manned by up to eight people on each side.

The remains of the old firehouse, which stood on Broad Street, are seen here following the fire of 1881. The tracks of the Syracuse Northern Railroad, which ran in front of the firehouse, are visible in the foreground.

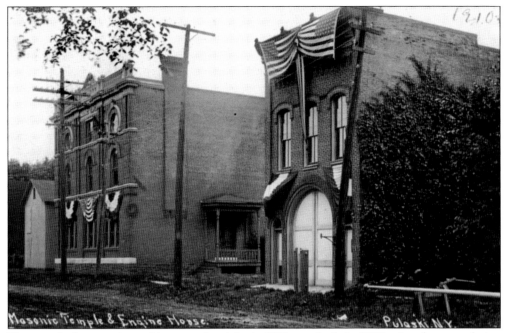

The new firehouse, pictured here on the right in 1910, was built in 1882 using the same design plan as the previous edifice. The building on the left is the Masonic temple. The Masonic order had been organized in Pulaski in 1816 and disbanded in 1835 during an anti-Masonic period. In 1857, a lodge was again chartered. The building was designed by Archimedes Russell, the cornerstone was laid in 1892, and the building was dedicated in 1893.

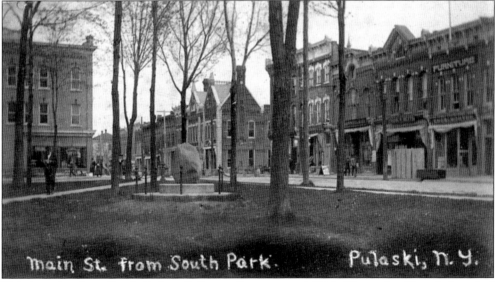

This is a view from South Park to Jefferson Street around 1912. The early village fathers had planned a continuous park from the courthouse to the Methodist church, as well as from Broad Street to the Salmon River. In 1814, the militia drilled here under Col. Thomas S. Meacham's leadership for the defense of the area from Fort Stanwix to Oswego and Sacket's Harbor. It was the site of the first store, a log cabin, in 1810. To the left is the Franklin Building, past the boulder is the Pulaski National Bank, and to the right is the Frank P. Betts department store.

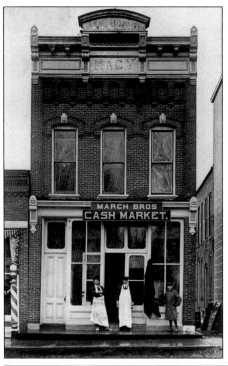

The Macy Building was constructed on Lake Street after the 1881 fire, and it faces South Park. The offices of the *Pulaski Democrat* were once housed here; Lawson Reade Muzzy took it over and made it an independent paper from 1869 through 1895. Besides the unidentified people standing in front of March Brothers Cash Market, there also appears to be a bear hanging upside down. (Courtesy of Andy Gibbs.)

Here, the same location has acquired the Pulaski Democrat name at the top of the building. To the left is an early office of the American Express Company, and a photography studio is at the end.

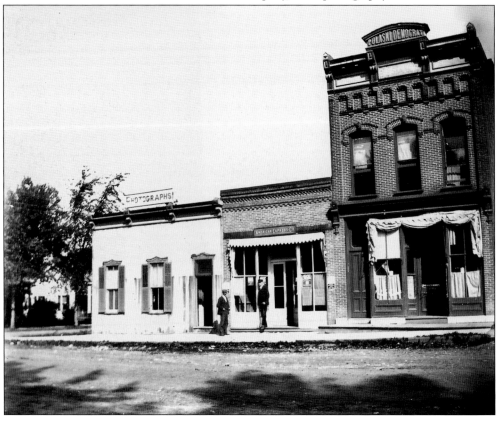

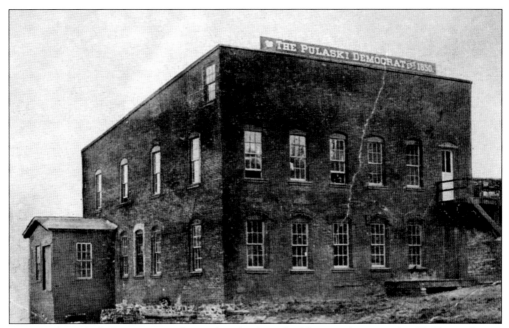

In 1860, the *Pulaski Democrat* was located in this large building on the east side of Jefferson Street, in the middle of the block. Stephen C. Miller, former principal of the Pulaski Academy, purchased the paper in 1855 and was the editor and publisher until his death in 1869.

In 1884, the *Pulaski Democrat* had moved to the second floor of the Box and Betts Block, which was built on Jefferson Street in 1882. John F. Box ran a grocery store, and Albert F. Betts was a tailor and clothier.

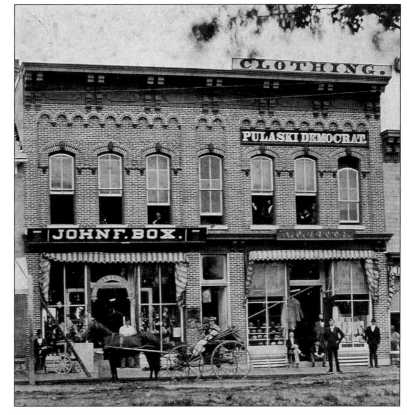

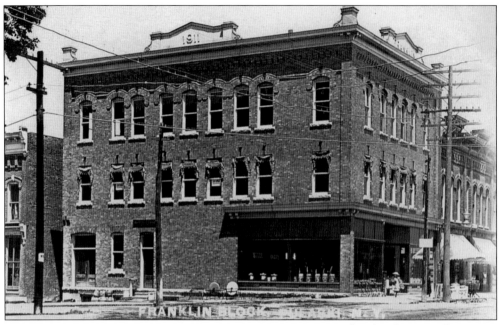

In 1911, Harrison R. Franklin built the Franklin Block at Lake and Jefferson Streets, a corner vacant since the fire of 1881. He moved his hardware store to the building and offered heating, plumbing, and electrical services. The window arches in the edifice contain iron acanthus leaf keystones. Franklin sold the business when he became interested in selling automobiles locally. (Courtesy of Lawrence Petry.)

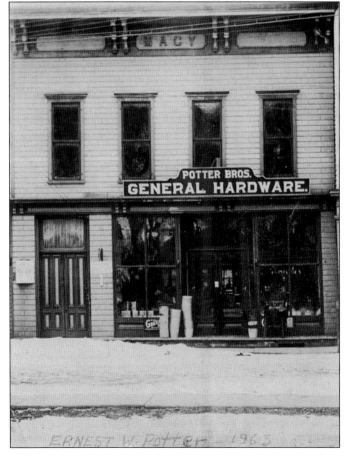

Another Macy-named building housed Potter Bros. General Hardware on Jefferson Street. Ernest W. Potter was a dealer in furnaces, stoves, plumbing, and hardware from 1906 to 1923. (Courtesy of Andy Gibbs.)

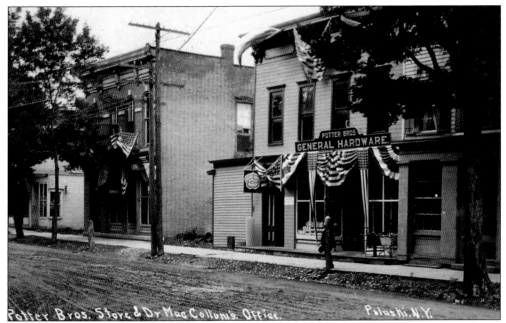

Upstairs over the Potter Bros. General Hardware store was the medical office of Dr. Fenton Elmer MacCallum, who moved to Pulaski in 1904. Later, this site became the location of the Mexico Motor Car Company. To the left is yet another location of the *Pulaski Democrat* office, where it was housed starting in 1917. (Courtesy of Dick Gorski.)

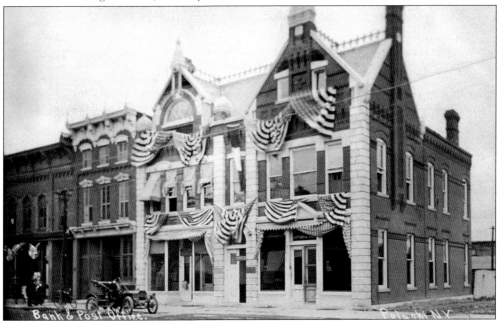

The Pulaski National Bank, seen here in 1897, is located on the east side of Jefferson Street. James Clark erected the brick building with Vermont marble trim in 1883 at a cost of $13,000. Designed by Syracuse architect Archimedes Russell, the 2.5-story building incorporates Queen Anne and High Victorian styles. The bank had been founded in 1862 as the James A. Clark & Company Bank. After a Depression-era closing, the building was later home to a bank again.

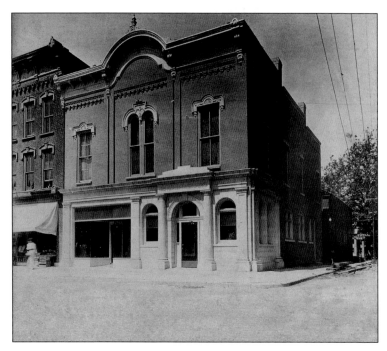

The Parkhurst Building was constructed in 1882, after the 1881 fire. The Peoples National Bank was organized in 1916 and was located at the corner of Jefferson and Park Streets. Harry A. Moody was its first bank president. The bank closed in September 1931, and the building was later used as the post office. To the left of the bank is John Gorman's store, and behind the bank is C.A. Jewell's general merchandise store.

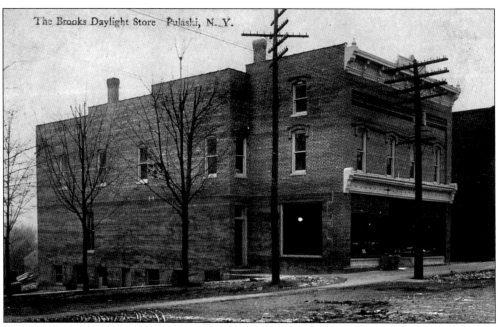

The Brooks Daylight Department Store was located at the corner of North Jefferson Street and Maple Avenue. Charles H. Brooks purchased the business from his father in 1909 and built on this location. At one time, the basement of the store became one of the first five-and-dime stores. (Courtesy of Andy Gibbs.)

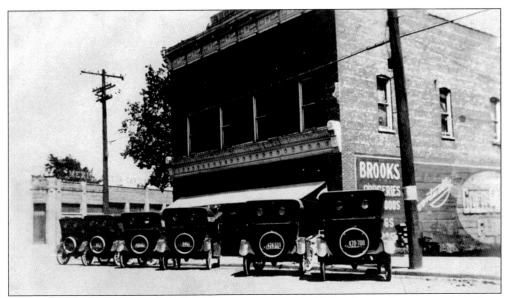

This view shows cars lined up at the Brooks store prior to 1927. The large, three-story edifice held an extensive supply of merchandise, from nuts and bolts to meats and groceries to furniture and kitchen supplies. The Mexico Motor Car and Supply Company can be seen across the street.

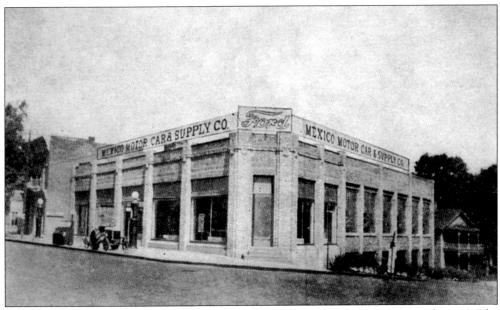

The Mexico Motor Car and Supply Company was established in Mexico, New York, in 1910 by John C. Taylor of Mexico and Justice Clayton I. Miller of Pulaski. They obtained a Ford franchise in 1914 and then opened the Pulaski branch in 1922. L.D. Tollerton bought control of the firm in 1936, and in 1937, his son Harry became manager of the Pulaski branch. The *Pulaski Democrat* office is on the left.

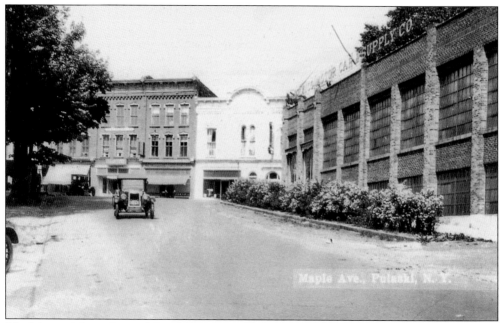

The Mexico Motor Car and Supply Company is seen here from Maple Avenue, looking west to Jefferson Street. The Peoples National Bank building gleams in the background.

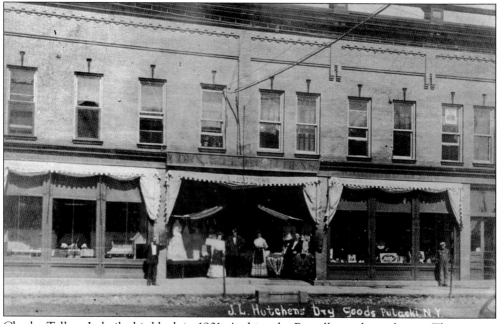

Charles Tollner Jr. built this block in 1901. Archimedes Russell was the architect. This section of the west side of Jefferson Street was the site of the "Original Bargain House," which had been established in 1886 and run by J.L. Hutchens. The Hutchens Block, as it was later called, was actually three distinct stores, although connected as one, with one large entrance. The three stores were arranged on the plan of the large, modern department stores of the day: the south store for dry goods; the middle store for notions, furnishing goods, and carpets; and the north store for boots, shoes, and cloaks. This view is from 1909. (Courtesy of Andy Gibbs.)

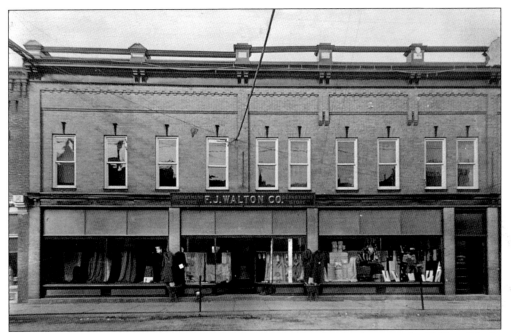

In November 1912, F.J. Walton took over the business of J.L. Hutchens in the Tollner Block. Walton had a business in Depauville and then worked for several years with the F.W. Woolworth Co. in Boston before coming to Pulaski. He operated the store until about 1922. (Courtesy of Andy Gibbs.)

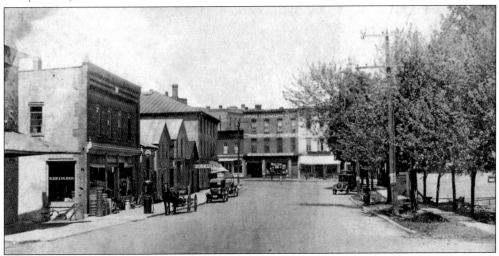

In 1911, Dwight C. Dodge replaced the original wooden structure with the brick building where Acker & Murray's is located on Salina Street. In 1919, Dodge sold it to James Acker of Pineville, who went into business with Andrew Murray of Edinborough, Scotland. For a long time, it had been a grocery or general store. In later years, it was the Silver Star Market, which closed in 1994. More recently, it became an auto parts store. At the end of the street is the Empire Vulcanizing Works, which was sold in 1921 to Albert W. Lewis, who had a plant on the street next to the George Hilton Market. Fred W. Sharp constructed the present wooden building. In 1890, William Henry Brown opened a harness shop at the location, which expanded to a hardware store when he bought the block in 1897. That business was sold to J.W. Edwards in 1962. (Courtesy of Dick Gorski.)

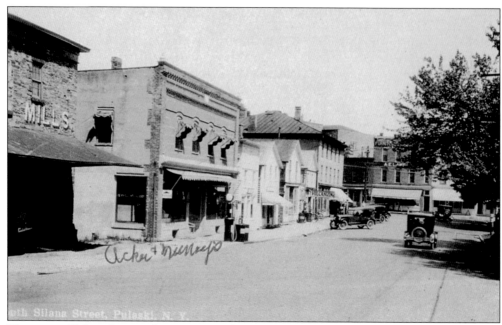

This view of Salina Street is from 1920. Frank E. Hohman sold Ontario Mills, at far left, to Walter J. Cuthbertson in 1905. At the end of the street is A.E. Lawrence's business. Albert E. Lawrence was a minister who also sold furniture and was an undertaker. In 1939, S.P. Walton of Mexico took part ownership of the undertaking business and transformed the George W. Douglas house on North Jefferson Street into a funeral home.

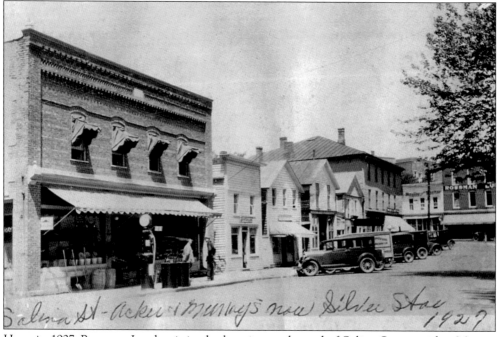

Here, in 1927, Rossman Lumber is in the location at the end of Salina Street, with a Maytag store to the left. To the right of Acker & Murray's is the A.W. Taylor store. Taylor was an expert worker in leather who had a shoe repair and retail shop.

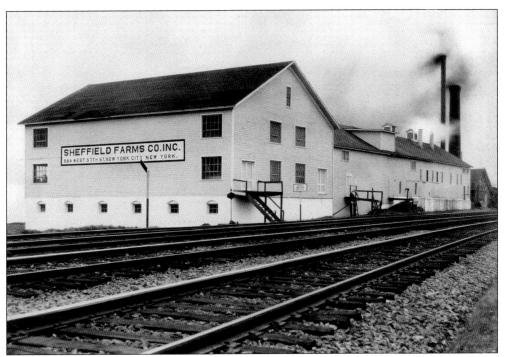

The Sheffield Farms Company was located on Rome Street and opened in 1936. Sheffield Farms made cheese, powdered milk, and condensed milk. In March 1950, the company moved to Lacona. The Sheffield Farms complex later became home to Deaton's Lumber Company. The railroad tracks in the foreground were originally for the Rome & Oswego Railroad and are now used by Conrail.

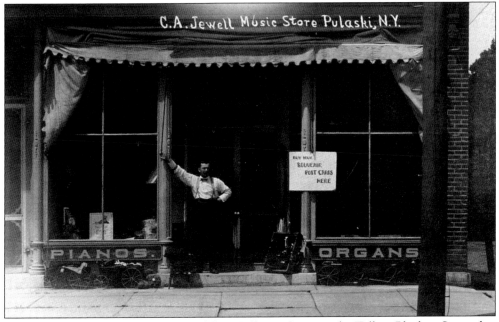

The C.A. Jewell music store was moved from Jefferson Street to the Tollner Block in September 1922. The business was more of a general merchandise store than just a music store.

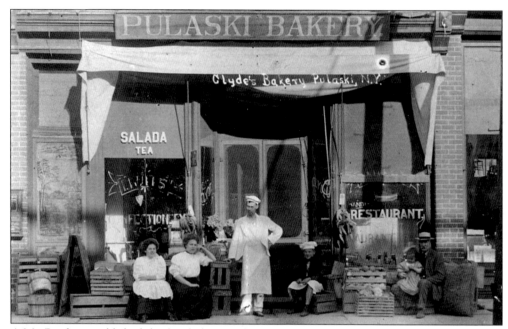

A Mr. Brasher established the first bakery at this site on the west side of Jefferson Street in 1893. Samuel J. Clyde bought the bakery in 1895 and enlarged it by selling fancy groceries and running a restaurant that served light lunches. It is seen here around 1912. It was later known as Petrie's Bakery, and it was Debbie Teachout's bakery in 1995.

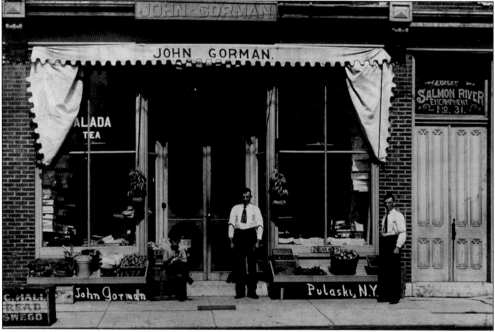

John Gorman of Hastings opened a grocery store in the R.W. Box building in 1902. This view is from the early 1900s. The business became Gorman & Bonner from 1921 to 1928. To the right is the doorway for the Independent Order of Odd Fellows (IOOF) Salmon River Encampment No. 31, chartered in 1893. (Courtesy of Andy Gibbs.)

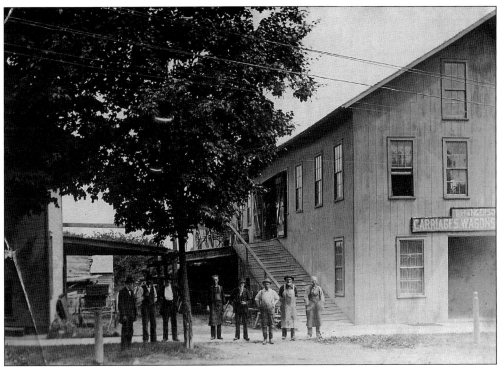

The Ingersoll Carriage shop was located on North Jefferson Street. Robert Ingersoll started the company in 1844, making milk wagons, carriages, sleighs, and buggies. The factory was destroyed by fire in October 1870. It was replaced in 1871 with a 2.5-story building that stood until 1979. His son-in-law C. Frank Woods joined him in the business in 1882. Pictured here in 1901 are, from left to right, Tom Ingersoll, Lewis Macy, Dennis Austin, unidentified, Lester Tyler, Charles Richardson, Henry Whitney, and Bill Gibbs.

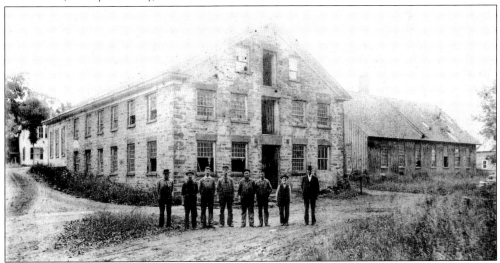

Benjamin Snow Sr. and William Greenwood established the Eagle Foundry for gunsmithing in 1832 on land donated by surveyor Benjamin Wright. In this image, Snow is second from the right. The foundry was located on the north side of Maple Avenue. Fisher & Ling owned the company from 1856 to 1886.

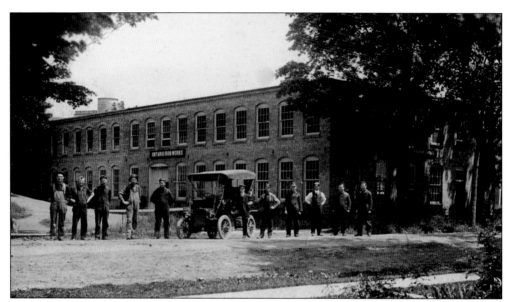

Fred Olmstead and his coworkers admire his new car in 1910. Arthur E. Olmstead of Orwell purchased the business in 1892, and it was called the Ontario Iron Works. The present two-story brick building was completed in 1901. The factory made tools and machinery and, later, farm plows and boilers. The design of the Ontario Iron Works buildings was typical of turn-of-the-20th-century steam-powered factories. Large windows allowed light and air to enter the workspace, while brick walls minimized the danger of fire. The business closed in 1963.

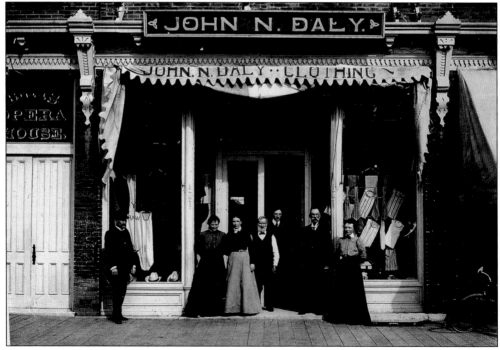

The John N. Daly Clothing store was located in the Betts Opera House block, as evidenced by the sign over the door on the left. Daly started in business about 1895 as a tailor specializing in men's clothing. The clothing store was located next to H.R. Franklin's Hardware.

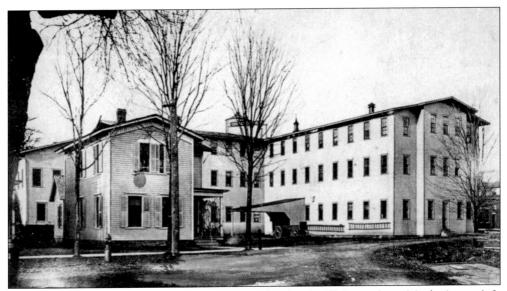

The Tollner Box Factory was located on the south side of Mill Street (now Maple Avenue). It was a major employer in Pulaski from 1875 to 1934. The company started making smoking pipes and then went into producing cigar boxes, home and store furniture, threads cabinets, ribbon cabinets, pencil boxes, counter trays, and gramophone cabinets for Columbia record players. All types of cabinet works were created here after 1864. (Courtesy of Lawrence Petry.)

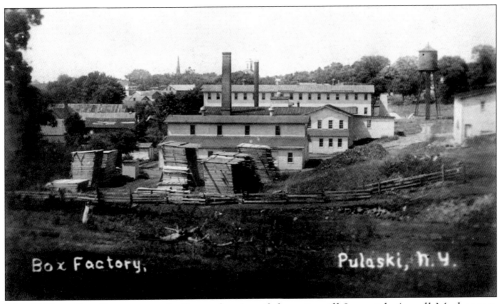

The Tollner Box Factory was built on the site of the gristmill Jeremiah Angell Mathewson constructed on the Salmon River in 1808.

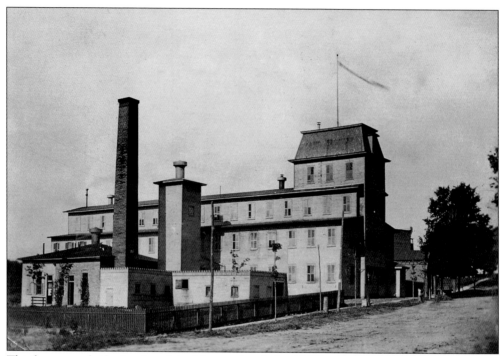

This factory was built after the original factory, founded in 1864 by Charles Tollner Sr., burned to the ground in January 1886. This is now the site of the End Zone Bar and the Cole Muffler Shop.

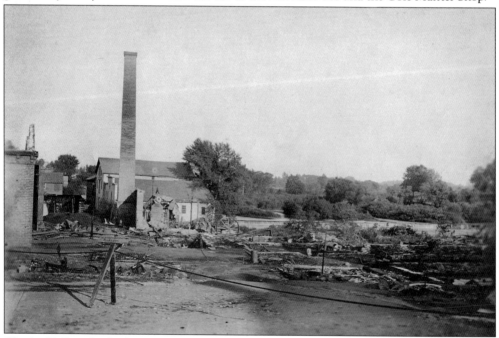

Charles Tollner Sr. died on July 15, 1897, at the age of 73. Charles Jr. died on January 10, 1902, at the age of 53. In February 1902, the plant was sold to Richard W. Box, Albert F. Betts, Louis J. Clark, and Irving G. Hubbs. The remains of the replacement Tollner factory are seen after it burned to the ground on September 7, 1902.

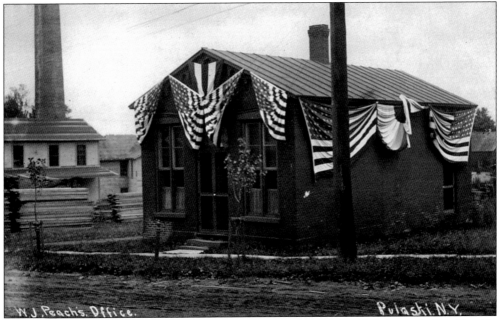

William J. Peach joined the Holmes Cheese Company in 1873. In 1912, he and G.D. Trimble bought the business. The office was located on Mill Street, along Spring Brook. (Courtesy of Andy Gibbs.)

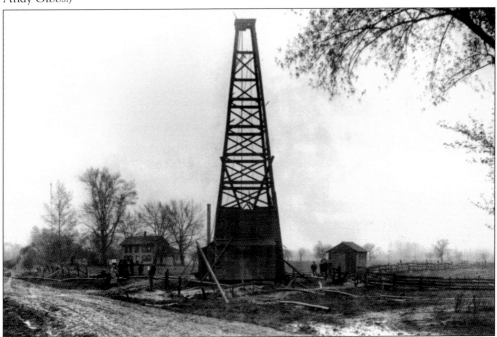

The Pulaski Gas & Oil Company, established in 1889, dug the first gas well on Mill Street (Maple Avenue) at the Lane farm. Louis J. Clark was the president of the company until the spring of 1894, when Charles Tollner purchased the franchise. Hardware merchant George W. Douglas purchased the company when Charles Tollner Jr. died in 1902 and continued drilling until 1925, when the business was sold to Clarence W. Hilton.

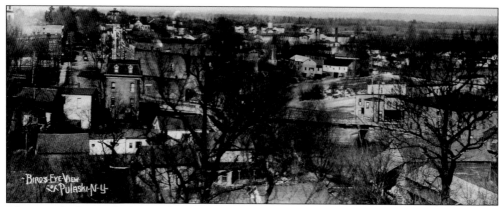

This view looks north along Jefferson Street's business district from the Pulaski Academy. The trees of South Park are seen on the left, with the steeple of the Methodist Episcopal church rising above. The Short Bridge is on the right, and the J.L. Hutchens House stands in the front center left.

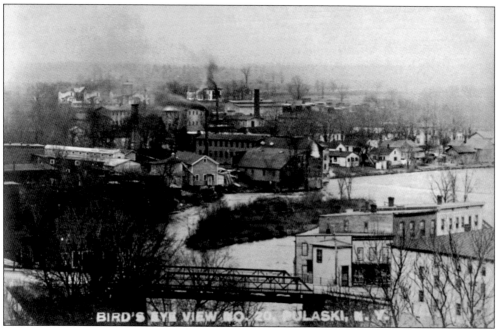

The waters of the Salmon River drew early settlers because they provided a natural source of power for various kinds of mills and businesses along its shores. This bird's-eye view looks over the Short Bridge to the factories along the river. The building jutting into the river, above the island, is the Salmon River Table Company. H.K. and Edward Seiter bought out Frank and Alan McChesney's table manufacturing business in 1906. The building was destroyed in a fire in 1927.

Two

NO PLACE LIKE HOME

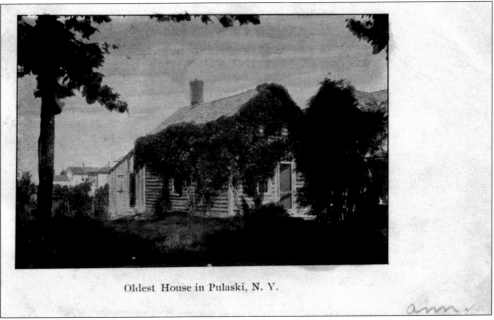

Oldest House in Pulaski, N. Y.

Eli Weed was a carpenter, like his brother James, and he lived in this frame house, the first such house in Pulaski, for 40 years. Later, his daughter Maggie Weed lived here. Erastus Kellogg, a blacksmith, built the house on North Street in 1816. It was torn down in 1931. This view is from about 1907. (Courtesy of Lawrence Petry.)

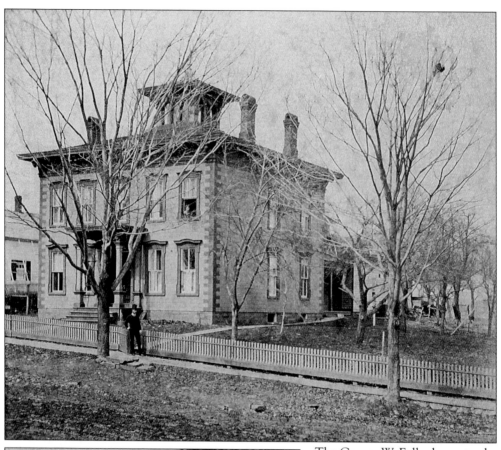

The George W. Fuller homestead, located on Lake Street, was built in the mid-1800s. Fuller was one of the pioneer businessmen of Pulaski, owning a dry goods store and then a hardware, stove, and tinware business before eventually getting into the drugstore business with his son. The house was sold to the American Legion in 1931 and later became an apartment building.

The Gillespie House, built in 1853, was the Franklin Taylor Funeral Home from 1947 to 1967. Robert Gillespie of Richland purchased the original 25 acres of land in June 1837. At one time, David C. and Mary Mahaffy lived in the house.

The Louis J. Clark house is pictured here around 1900. Known as the Clark-Thompson House, it was built in 1868, with elaborate window details, a bracketed roof, and a cupola. It has three marble fireplaces, as well as a carriage house to the rear. Builder James A. Clark was from a prominent family of bankers who established the Pulaski National Bank. It was later the home of Dr. Alton Bernard Thompson, who lived in Pulaski starting in 1930 and practiced medicine from his office here for more than 60 years.

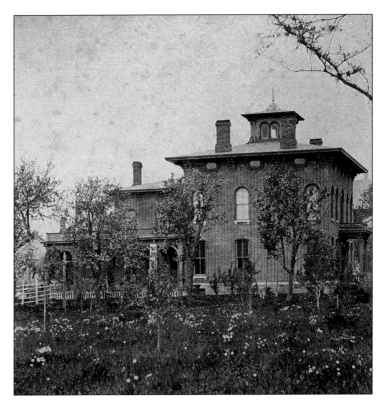

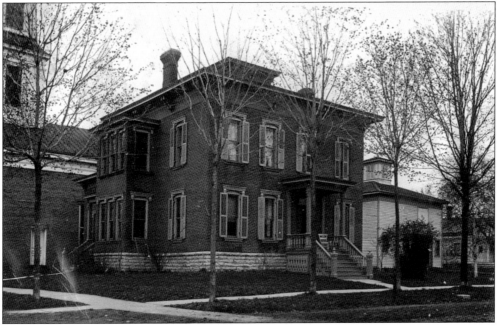

Dr. Henry Caldwell built this two-story, brick house in 1891 at the corner of North Jefferson and Hubble Streets. Caldwell served in the Civil War and moved from Florence, in Oneida County, to Pulaski in 1872 to open his medical practice, specializing in cancer treatment. To the left of the house is the Methodist church.

The Clark-Campbell House on James Street is an example of an upright and wing-style house. It was built by Charles A. Clark after the Civil War. The octagonal outbuilding was a chicken house constructed before 1885 in Gothic style with board-and-batten siding, while the cupola and eave brackets suggest an Italianate influence. It is said to have housed the fighting gamecocks of the Clark family.

Merchant Henry B. Clark built this Victorian-style home on North Jefferson Street in 1889. His daughter and family, the Frank P. Betts, lived on the second floor, a duplicate of the first floor. The architect, Archimedes Russell of Syracuse, also drew plans for Pulaski's Masonic temple, the Pulaski National Bank, the Irving Hubbs home, and the Tollner-Jewell Block.

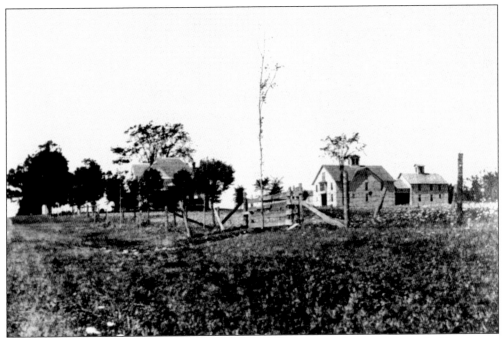

The Moody farm was built around 1840. It was located on Route 13, east of where the Douglaston Manor driveway is today. The house was torn down in 1930. H. Douglas Barclay, a former state senator, is the seventh generation to live on these lands, purchased in 1808 by his ancestor Col. Rufus Price, a soldier in the American Revolution and an aide on Washington's staff.

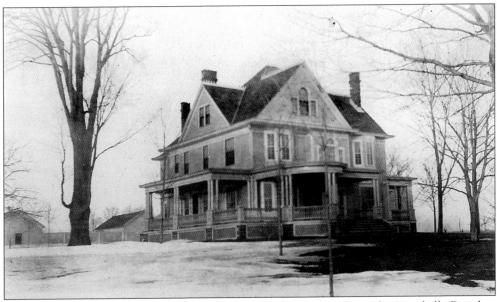

This Victorian house was built in 1903 for Harry A. Moody and his wife, Annabelle Douglass Moody, of Brooklyn and Pulaski. It was located on Route 13 between Route 3 and Pulaski. Moody worked with Frank Woolworth when they were teenagers, and in 1895, Moody started an association with Woolworth's five-and-dime store.

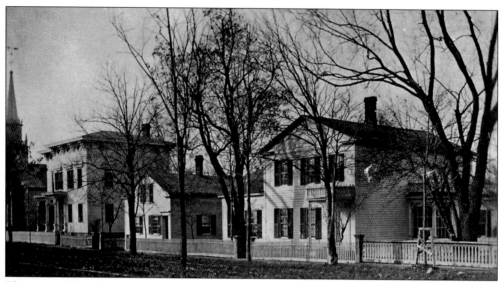

This view of Broad Street from around 1890 is looking south. The old Baptist church is at the far left. Next is the Baker-King house, built about 1870 at the corner with Bridge Street. Don A. King was a founder of the Pulaski Academy and a partner in the R.L. Ingersoll & Company bank. He also built the J.L. Hutchens home for his daughter and son-in-law. T.C. Baker, King's father-in-law, was credited with choosing the name of Pulaski at a village meeting. The home on the right belonged to A.R. Angell around 1860.

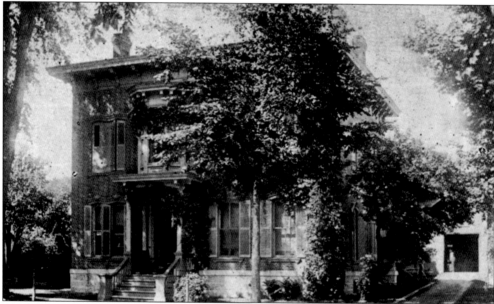

This house was once located across from the Thompson House on Lake Street. It was built in 1878 and belonged to Dr. Frank S. Low and his brother, who had offices there. Dr. Low, a general practitioner, came to the village in 1855 and served as county coroner, sheriff, and president of Pulaski Academy. Later, Dr. Frederick W. Crocker occupied the house, where he practiced medicine from 1918 to his death in 1930. The Pulaski Independent Order of Odd Fellows and Rebekah lodges purchased the site in September 1939. The building was demolished in 1989, and it is now the location of the new Ringgold Fire Company building, constructed in 1998. (Courtesy of Lawrence Petry.)

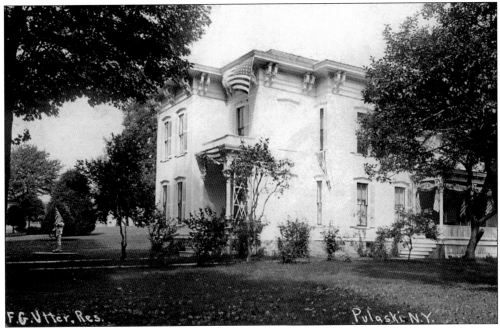

The home of Fillmore G. Utley on Jefferson Street featured an interesting statue, pictured here on the left. It was a fountain of a boy holding up his leaking boot. F.G. Utley owned the feed mill on the west bank of the Salmon River, on River Street. Charles Tollner Sr. later owned the home.

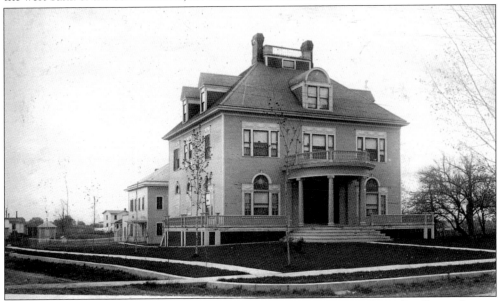

The Tollner-Richardson House is on the southeast corner of Delano and North Jefferson Streets. This American Four Square–style house, with engraved glass panels on either side of the front door, was built in 1896. Charles Tollner Jr. built a wide central hall with a staircase to an area with a pipe organ. Anson Maltby built the fireplace of field cobbles and redbrick. Tollner returned to Pulaski from New York City in 1896 to manage the business originally established by his father. In 1906, Hartwell Douglass bought the home, and in 1925, A.F. Keough converted the building into a hotel.

The Macy home is located on Broad Street, across from the courthouse. Lewis J. Macy bought the hardware and plumbing business of Henry Lyman and Alfred Beadle in 1882 and continued the business until 1904. He was an active Mason, served four years as the Town of Richland supervisor, and joined the Pulaski Fire Department in 1869, serving until 1885. He later became involved in the insurance business. Eastern Shore Insurance now occupies the building.

The Brooks-Parkhurst House is on North Street. Deloss Brooks purchased the house in 1890, and it was later owned by his granddaughter Edna Brooks Parkhurst. The Brooks family ran the Brooks Daylight Department Store at the corner of North Jefferson Street and Maple Avenue.

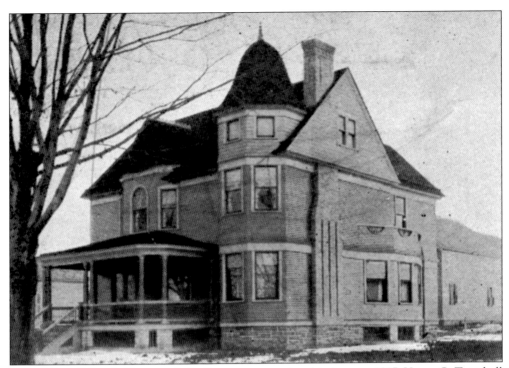

The William J. Peach House on Lake Street was completed in January 1897. Henry C. Twitchell was the master builder, the masons were William Peach Sr. and Anson A. Maltby, R.D. Box and his son were the painters, and Lewis J. Macy was the tinner. All of them were from Pulaski. In the Eastlake architectural style, it was furnished with 48 electric lights and five gaslights. This view is from around 1905. At the time, William Peach was the village president, secretary of a local electric light and power company, and a successful cheese broker. Robert Thomas later owned the house. (Courtesy of Lawrence Petry.)

The George W. Douglas Home, pictured here in 1907 on North Jefferson Street, was one of the largest houses in the vicinity. Douglas was a hardware merchant and mill owner until he acquired the Pulaski Gas & Oil Company. For 20 years, he was a director of the Peoples National Bank. The house became the Walton and Lawrence Funeral Home in 1939. (Courtesy of Dick Gorski.)

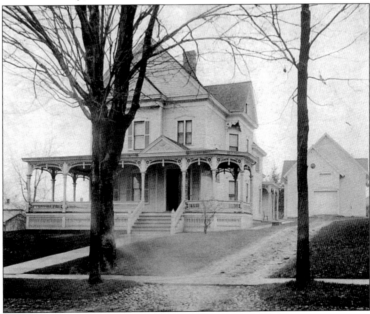

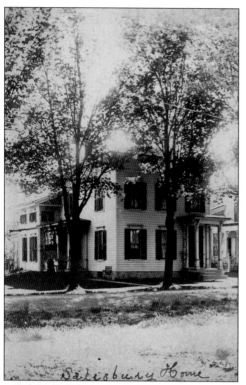

Salisbury Home

The Salisbury home, located on Park Street, was purchased by William J. Peach in 1918 and then by Addison Stearns in 1926. Dewey C. Salisbury owned a tannery and leather manufacturing business in 1844, and Brayton Salisbury was a cheese maker, with a business at North and Salina Streets. (Courtesy of Dick Gorski.)

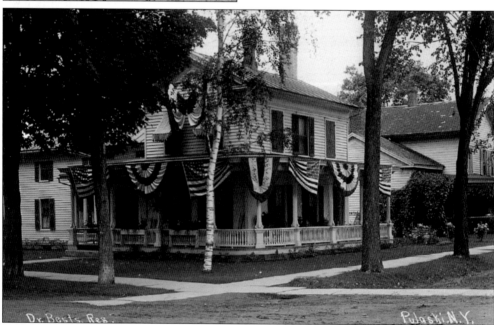

The George W. Betts house, pictured here around 1909, was located at the corner of Broad and Lake Streets. Dr. Betts practiced medicine with his father, James N. Betts, from 1880 until the death of the elder Betts in 1892. In 1918, Dr. Franklin Coburn rented the house and practiced medicine in the village. The home later became a five-family apartment house, and it was gutted by fire in November 1950. The site became part of the new Ringgold Fire Company building.

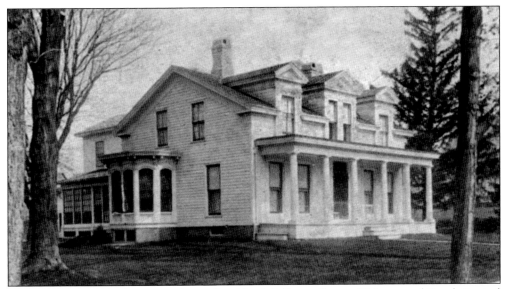

The Ling-MacCallum House was located on North Jefferson Street. This unusual Greek Revival house with bay windows, dormers, and a striking portico once belonged to Lorenzo Ling, who became a partner in the Ontario Iron Works in 1856. Plans for this house appeared in Edward Shaw's *Modern Architecture*, published in 1855, the year before Ling's arrival in the village. This house retains the simple Doric facade, three dormers, and strong horizontal lines of Shaw's original design, but well-defined moldings outline all the front windows and the door. The builder also doubled the size of the center dormer and added heavily molded pediments to the dormers. It was the home and office of Dr. Fenton MacCallum before World War II.

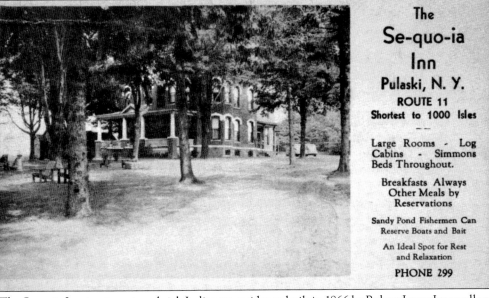

The
Se-quo-ia
Inn
Pulaski, N. Y.
ROUTE 11
Shortest to 1000 Isles

Large Rooms - Log Cabins - Simmons Beds Throughout.

Breakfasts Always
Other Meals by
Reservations

Sandy Pond Fishermen Can
Reserve Boats and Bait

An Ideal Spot for Rest
and Relaxation

PHONE 299

The Sequoia Inn is a two-story, brick Italianate residence built in 1866 by Robert Leroy Ingersoll on North Jefferson Street. The brick probably came from a brickyard east of the residence. A cupola graces the roof, and an 1885 map suggests there was a horse racing track nearby. Ingersoll came to Pulaski in 1847. He started the Pulaski Bank, which was Pulaski's first bank, in 1854, as well as the Ingersoll and Larrabee carriage factories. In 1994, the inn became a bed-and-breakfast.

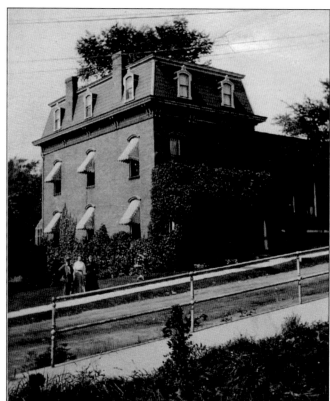

The James Lovell "J.L." Hutchens house was built by his father-in-law, Don A. King, and was located at the corner of Bridge and Jefferson Streets. The house was later owned by dentists Minor Terry and John Abbott. In 1988, Linda Tarbox established it as the 1880 House bed-and-breakfast.

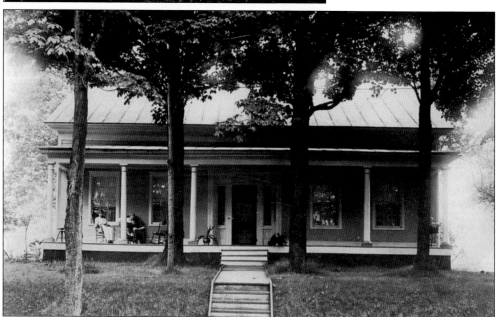

The Frederick Grant Whitney house is similar in design to Woodlawn, the home of Gilbert Allen Woods, which was built between 1837 and 1840. Whitney was a village attorney from 1902 to 1906 and served as a member of the New York State Assembly from 1904 to 1908. The house later became the Evergreen Nursing Home. Whitney died there in 1958 at age 90.

Three

PORT ONTARIO AND SELKIRK

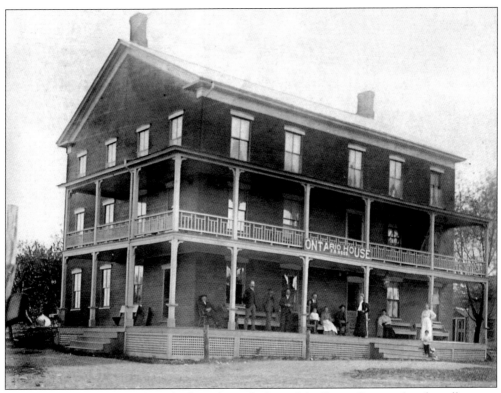

The old Commercial Hotel was built in the early days of the "boom," soon after the village was incorporated in 1836. In 1890, William Place of Jefferson County purchased and renamed it the Ontario House. He also added large, two-story porches on the north and west sides of the hotel. The whole upper floor of the hotel was a large ballroom, where dances were held with as many as 200 attendees. Mr. and Mrs. Fred R. Wood bought the Ontario House in 1906. Charles Mosher was the last proprietor when the building burned in a fire in 1917. This photograph is from about 1910. (Courtesy of Dick Gorski.)

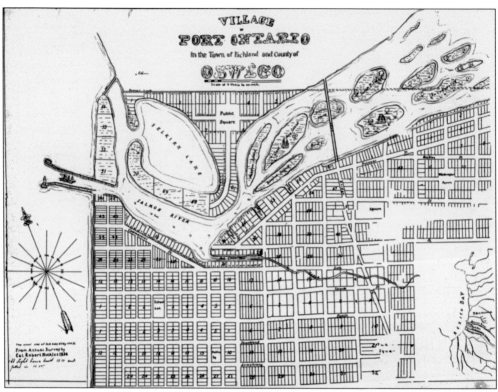

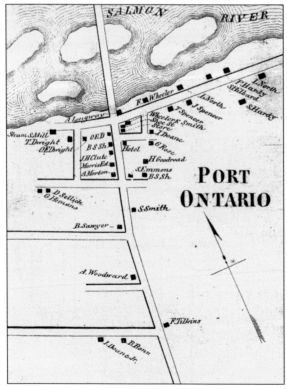

This is a copy of the hand-drawn map Col. Robert Nickles made in 1836. About that time, a group of promoters conceived the idea of building a city at the mouth of the Salmon River. The contemplated city of Port Ontario was surveyed and plotted into 125 half-acre lots and 66 five-acre lots. Roads were also laid out on paper. On April 10, 1837, the Port Ontario Hydraulic Company was incorporated with $100,000 in capital. Its purpose was to construct "a canal from the falls below Pulaski to the village of Port Ontario, along the banks of the Salmon River." This was to supply Port Ontario with waterpower.

This is how Port Ontario actually looked in 1867. Efforts to develop Port Ontario fell through following the financial crash of 1837.

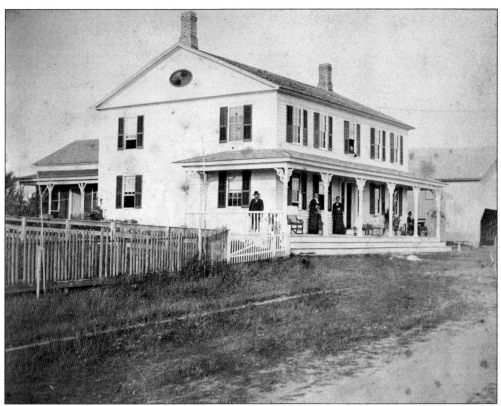

The A.D. Herrington home was a store and a hotel in 1897. Located on the east side of Route 3, Fred Herrington ran the grocery store. It was converted to a bar by James Walker and was later run by his brother Homer in the days of the Civilian Conservation Corps (CCC) working at the state park.

The early bridges in Port Ontario were constructed as toll bridges over the Salmon River, replacing Brown's toll ferry. They were located on Route 3, originally a military road that connected Fort Oswego with the fort at Sacket's Harbor. The stone abutments were built in 1883 and linked with iron spans and supports for the wooden deck. The bridge was replaced in 1932, and two new spans were eventually constructed a little farther upstream in 2001. On August 11, 1846, the *Oswego Palladium* wrote, "To reach [the Port/Harbor] we cross a formidable bridge, 84 rods in length, and for the privilege of so doing are required to fork over a penny."

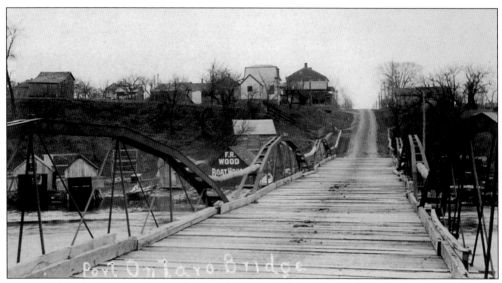

In its heyday, Port Ontario boasted of two hotels: the Port Ontario House, operated by Fred R. Wood, and the Selkirk House. These establishments catered to vacationers, travelers, and people seeking weekend relief from the summer heat. Wood's boathouse is to the left of the bridge, and the Ontario House is at the top of the hill. In the early 1900s, the Port Ontario House was known for its lively Saturday night dances.

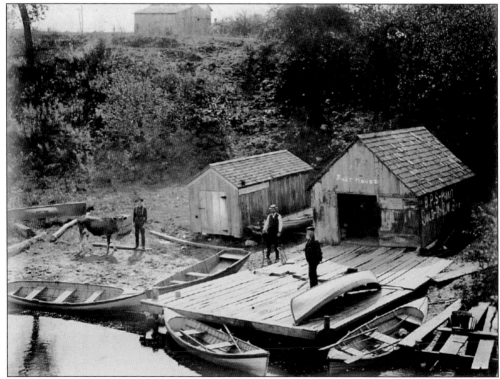

Some of the boat docks are in view here at Port Ontario. Port Ontario is a reminder of the busy shipping days of the 19th century, when agricultural and wood products were shipped by Lake Ontario and the Oswego Canal to the East Coast.

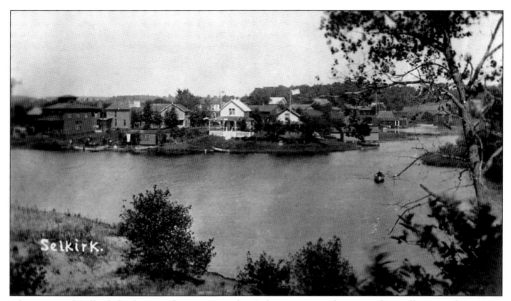

This view of Selkirk looks east from across the Salmon River, showing the Tollner-Fitch cottage on the far left and the Clark's Cottages complex in the center.

Selkirk was probably named for Thomas Douglas, Earl of Selkirk, who owned 4,388 acres of land on the north side of the Salmon River. He purchased the land in the late 1790s from William Constable and made himself a sizeable fortune in subsequent real estate sales. Owen Morton built the cottage on the left about 1925. The Selkirk Lighthouse is on the right.

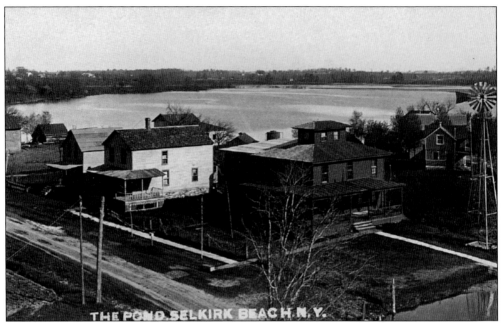

THE POND, SELKIRK BEACH, N. Y.

In the late 1800s, it became fashionable to build summer homes or cottages at Selkirk. One of the more elegant cottages was that of Charles Tollner, overlooking the Salmon River across the road from the lighthouse. Harriet Fitch purchased the cottage in 1903. She was well known in the development of Selkirk Beach as a summer resort. This photograph from about 1915 shows the large cottage, with the windmill in front, on the right. The white house to the left was the McChesney store, which later became one of Clark's cottages.

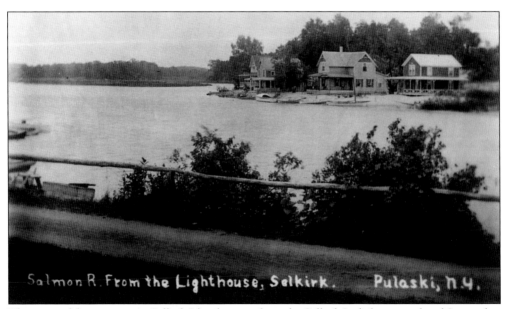

Salmon R. From the Lighthouse, Selkirk. Pulaski, n.y.

This view of the cottages on Selkirk Island, across from the Selkirk Lighthouse, is dated September 22, 1908. Charles Roth moved to Pulaski in 1918 and purchased the island. Roth was a veteran of the Spanish-American War and, later, a music publisher. He died in 1959 at the age of 92.

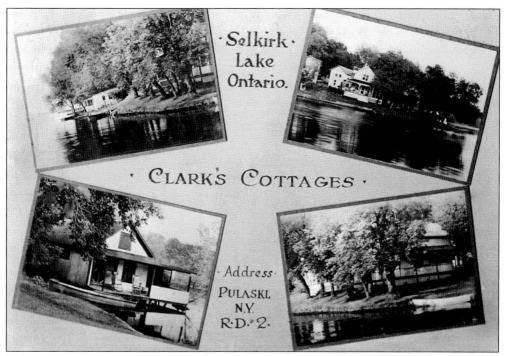

Many of the cottages near the lighthouse that were built in the early 1900s are occupied by descendants of original or early owners. This early view is of several of Clark's Cottages, which are still being used as rental properties. Cora Flossie Macy Clark, the wife of F.C. Clark, inherited some of the cottages from her parents. Her great-grandfather William F. Austin bought the original lots in 1898. The Austins and the Macys built three of the cottages, and in the 1930s and 1940s, the Clarks bought the others. The cottage in the bottom left stood over the river. It is now rented to the Selkirk Yacht Club.

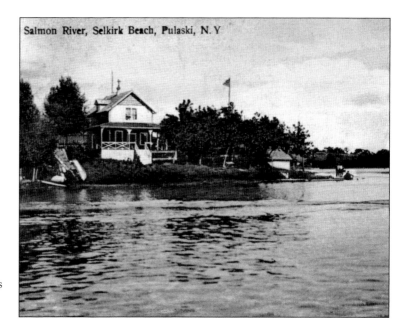

This cottage is called Pleasant View. It was built by Lewis J. Macy in 1902 and is part of the Clark's Cottages group. (Courtesy of Lawrence Petry.)

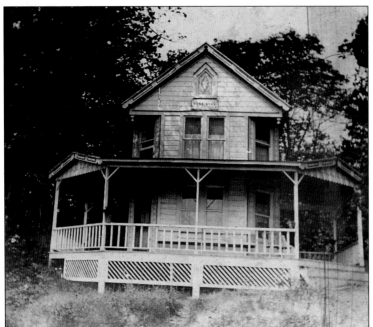

The Edgewood Cottage is pictured here in 1908. The message on the postcard says, "Edgewood Cottage Selkirk Point, NY. Rents for $12 per week, furnished, boat, etc. Write S. K. Ingersoll or Mrs. Katie Ingersoll. Parties carried to & from Pulaski Station for 25 cents each or 50 cents round trip."

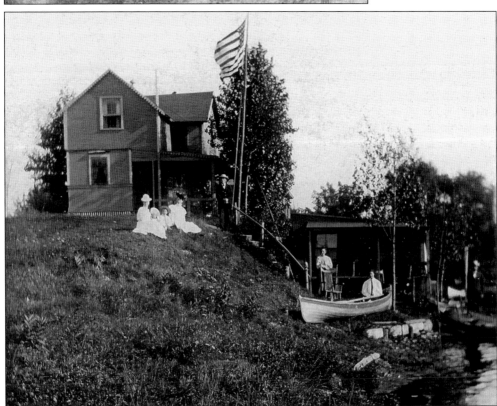

William Fayette Austin's cottage is pictured here in 1905. Austin had a sash and blind factory on Mill Street in Pulaski that he leased to Charles Tollner so Tollner could keep up the production of boxes. Austin sold his stock of groceries and crockery to Malcolm L. Hollis in 1877.

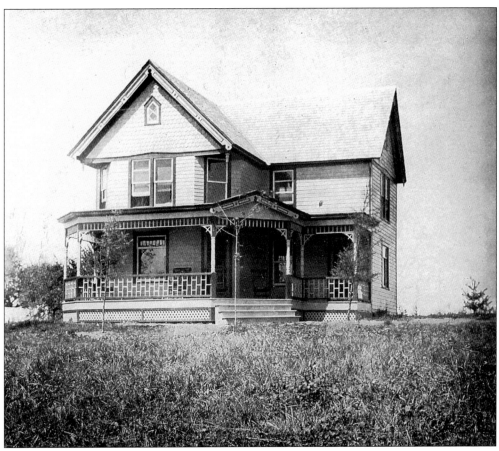

W.E. Nelson's cottage, seen here in 1906, was used for summer tourists. Nelson was an active farmer in Selkirk and a town board member for 30 years. In 1901, George Seiter of Selkirk bought the Selkirk schoolhouse, which Nelson owned, and moved it to the northwest corner of Route 3 and Selkirk Beach Road.

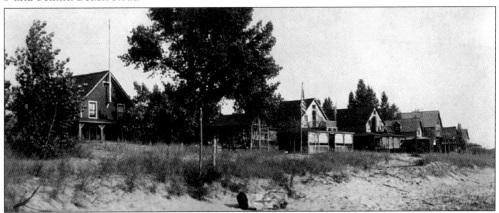

Along the lakeshore, a number of summer tourist and residential lake colonies developed about 1900, including Ramona Beach, Pine Grove, and Selkirk Beach. By 1921, there were about 150 cottages on the lake and river, with about 500 people spending part of their summer at the various locations.

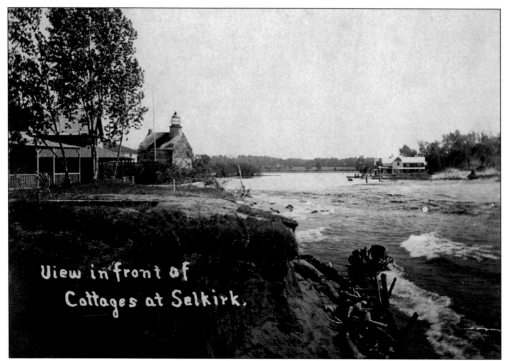

This is a view from the cliff looking south, back towards the Selkirk Lighthouse and the cottages on the beach at right.

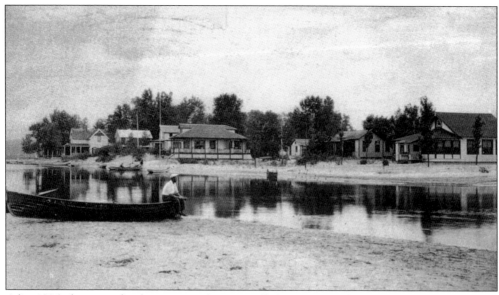

After 1896, there was development at what was called Pine Grove, located on the south shore of the Salmon River near Mud Creek. Pine Grove included the Hubbs cottage and several boathouses and was a popular place for Pulaski groups to have gatherings in the grove. A hot dog stand was put up there, and it later became a cottage. There were clay tennis courts as well. Rowboats were rented and stored in a large building near the grove.

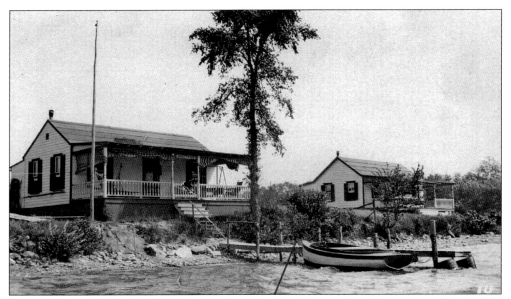

Pictured here is the Bright Wood Cottage (left), along with an unidentified cottage. Some of the cottages were quite elaborate on the Pine Grove side. Henry Fonda, a building contractor and manufacturer from Syracuse, purchased several beachfront campsites and built what was known as the "Spanish Castle" in 1928. (Courtesy of Lawrence Petry.)

The Frary (left) and Shaw cottages are shown here in the summer of 1909. John A. Frary was secretary of the Pulaski Grange, which was organized in 1891. He was a local farmer who also kept bees. Edith Frary was a longtime telephone company worker. (Courtesy of Lawrence Petry.)

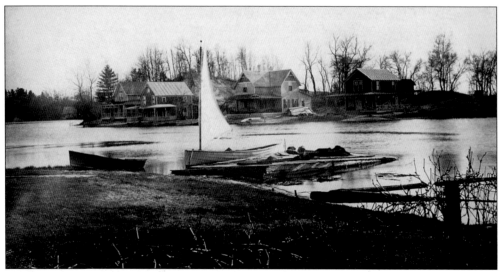

This photograph dates to about 1914. This was a popular place for painters of the area, as there were islands in the Salmon River, water lilies, and a small bridge for the cars of the day. Boating to the lighthouse was also very popular, although the building had been decommissioned before the Civil War.

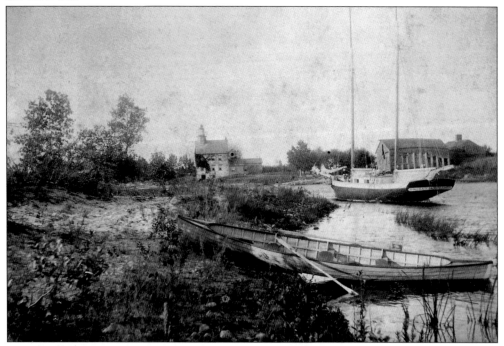

The old lighthouse, at Selkirk near Pulaski, was built to help lake schooners find the entrance to the Salmon River to get to Port Ontario. *Rhoda of Sacket's Harbor* is pictured here around 1860. Before the railroads were built, Port Ontario was the main way farmers and merchants got their products to city markets. Probably the most memorable event in Selkirk was the loading of a 1,400-pound cheese wheel (one big cheese!) on the schooner *North America*, bound for Oswego. Col. Thomas Standish Meacham produced the cheese as a gift for Pres. Andrew Jackson's inauguration in 1837. The loading was done at a dock in front of Clark's Cottages.

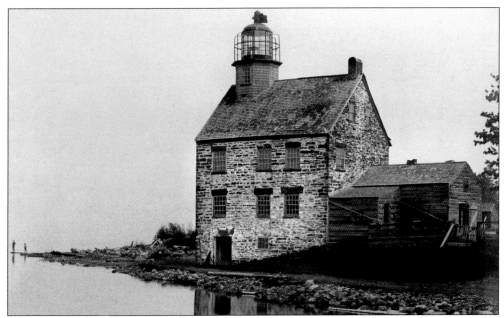

The federal government purchased approximately 5,670 square feet of land for the lighthouse from the Sylvester and Daniel Brown families on September 1, 1837. It was originally called the Salmon River Light Station and was constructed of local stone in 1838 for the sum of $3,000. Jabez Meacham was the builder. It was built on Lake Ontario at the mouth of the Salmon River. Lewis Conant was the first lightkeeper, serving until 1849.

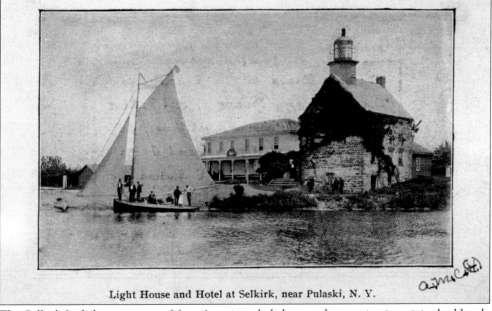

Light House and Hotel at Selkirk, near Pulaski, N. Y.

The Selkirk Lighthouse is one of four American lighthouses that retains its original, old-style "bird cage" lantern room. It was originally equipped with eight lamps and 14-inch reflectors, and it burned whale oil. In 1855, the lamps were replaced by a sixth-order Fresnel lens with a fixed white light 49 feet above the waters of the Salmon River. The lighthouse was decommissioned in 1838, but it was relit in 1989.

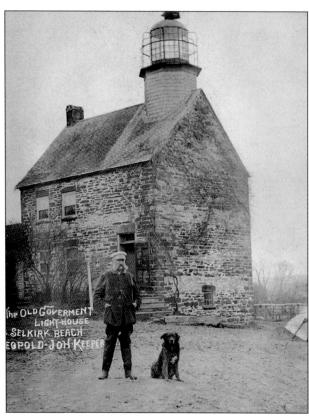

After the Selkirk Lighthouse was decommissioned in 1858, Leopold Joh purchased it in 1890 to use as a residence. Joh was born in Germany in 1838. He became a resident of New York City in 1865, moved to Syracuse in 1866, and then to Selkirk in 1895. In 1899, he built the Lighthouse Hotel.

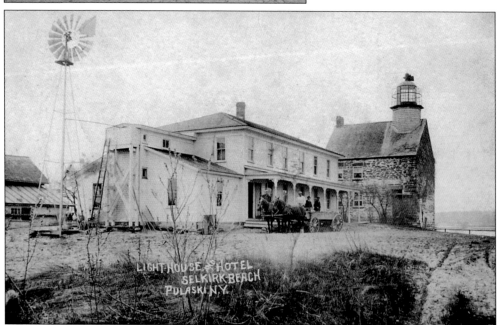

Guests regularly came to the Lighthouse Hotel from New York City, Baltimore, Oswego, and Syracuse. They would arrive by train in Pulaski and be transported by carriages to the hotel. Sailboats and rowboats were available for use at the hotel.

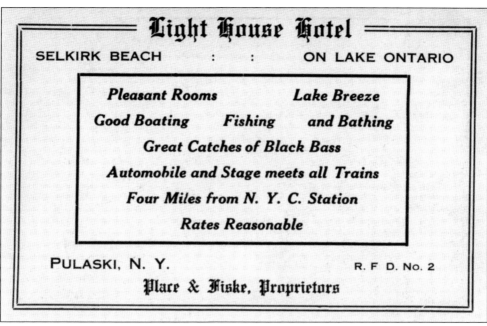

This is the back of a postcard showing the amenities of the Light House Hotel. In 1909, when Place and Fiske were the proprietors, they closed the hotel and returned to Watertown.

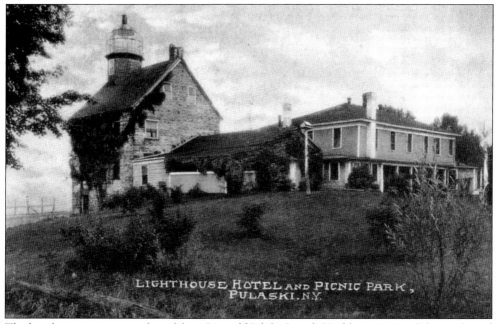

The hotel property was purchased from Leopold Joh by Joseph Heckle in 1916 and then enlarged 10 years later. The hotel gained a reputation for its German American cuisine.

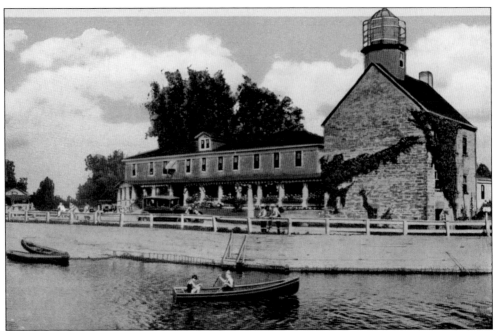

The lighthouse and the hotel are seen on this postcard postmarked August 30, 1934. Joseph Heckle operated the property until his death in 1954. (Courtesy of Lawrence Petry.)

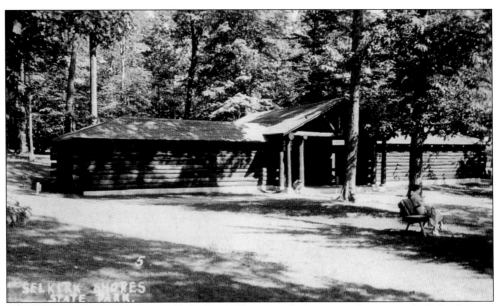

Selkirk Shores State Park was established in 1925 to provide recreational access to the Lake Ontario shoreline. Between 1927 and 1928, the Administration Building log cabin was constructed for the future Selkirk Shores State Park. In 1933, Civilian Conservation Corps (CCC) Camp Company 1204 was established at the park. This CCC group developed the campgrounds between 1933 and 1937. The first 12 cabins for tourists at Selkirk State Park were completed in 1935 by the CCC. Another 24 cabins and the park superintendent's house were completed by 1939. Pictured here is the bathhouse. The cabins were for summer month-to-month rentals at $10 to $15 per month.

Four

ALL AROUND RICHLAND TOWN

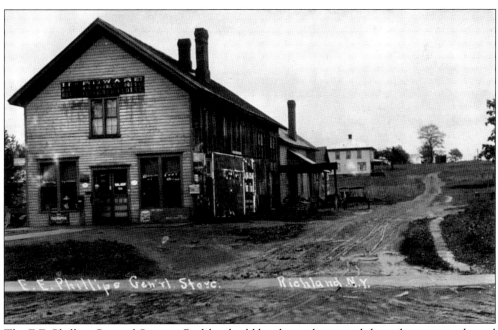

The E.E. Phillips General Store in Richland sold hardware, boots and shoes, harness goods, and general merchandise. It was also a post office in the early days of the 20th century. The store had a closing-out sale in August 1918. (Courtesy of Andy Gibbs.)

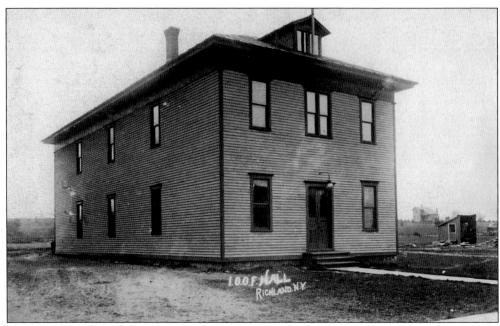

The hamlet of Richland had its own Independent Order of Odd Fellows Hall, Spring Brook Lodge No. 646. It was a popular place for dances and medicine shows. (Courtesy of Andy Gibbs.)

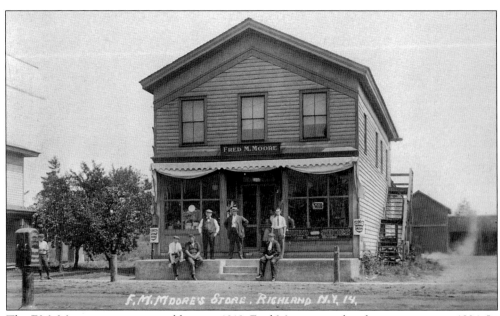

The F.M. Moore store is pictured here in 1919. Fred Moore was also the postmaster in 1894. In 1923, Edward T. Wilson became a partner, and the business was later called Wilson's Red & White grocery store. The building burned in 1950. (Courtesy of Andy Gibbs.)

One of the early Richland hardware stores is seen here. It sold boots, shoes, harness goods, and general merchandise. (Courtesy of Dick Gorski.)

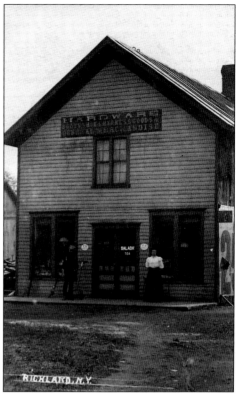

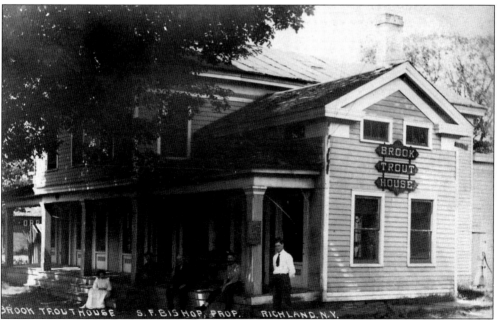

Henry H. Mellen built a hotel on the east side of the railroad tracks in 1853, and it became the Brook Trout House in 1908. He was a hotelkeeper, station agent, and postmaster. Summerfield F. Bishop, son of Capt. Ira Bishop, bought the business in 1894 and was the proprietor at the time this photograph was taken in 1910. (Courtesy of Dick Gorski.)

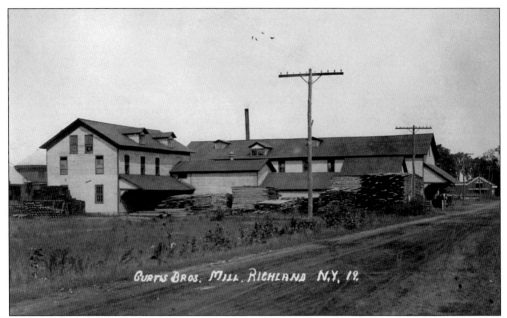

The Curtis Bros. Mill in Richland is seen here in 1913. The mill produced office and school furniture. The mill and spring bed factory were saved from a fire in April 1911 that burned at the restaurant across the tracks because the wind was blowing in the opposite direction. (Courtesy of Andy Gibbs.)

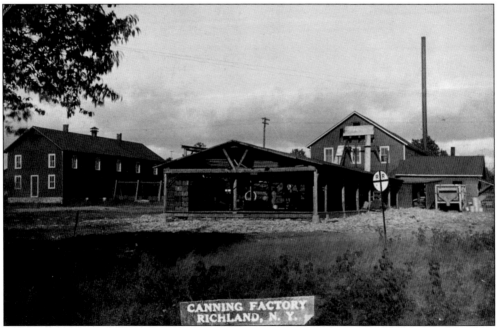

The Richland Canning & Preserving Company, Ltd., is seen here about 1923. The business was formed in May 1894 and opened for business that autumn. G.B. Washburn was the company's first president. It contracted for 300 acres of local sweet corn, putting up 15,000 cans of corn daily and employing about 50 workers. Louis J. Clark was one of their representatives. (Courtesy of Andy Gibbs.)

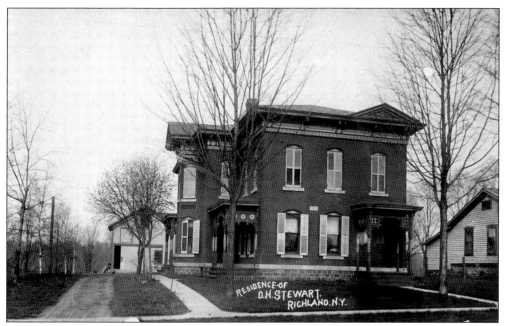

The Stewart-Compton House on Stewart Street, in the village of Richland, was built in 1886. The two-story, brick Italianate house, seen here about 1907, has a stone plaque with "M.L.S." and "1886" in-set in the front wall.

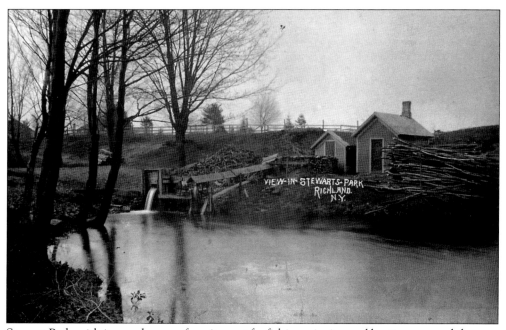

Stewart Park, with its ponds, was a favorite spot for fishing, picnics, and baptisms around the turn of the 20th century. (Courtesy of Dick Gorski.)

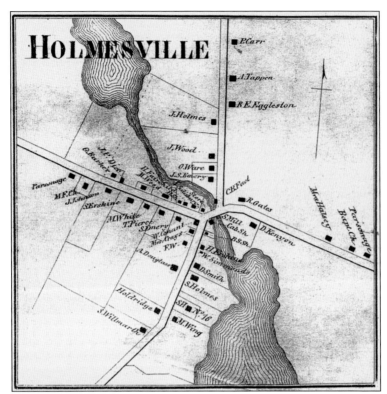

HOLMESVILLE

This map shows Holmesville in 1867. Members of the Holmes family came here from Pomfret, Connecticut, in 1807. The place that had been known as Holmesville and South Richland took on the name of Fernwood on October 2, 1899. The Saturday before, the community held a jubilee over the name change, with a bonfire, booming cannons, and fireworks. A.B. Caulkins was elected the new mayor by a majority of 45 votes.

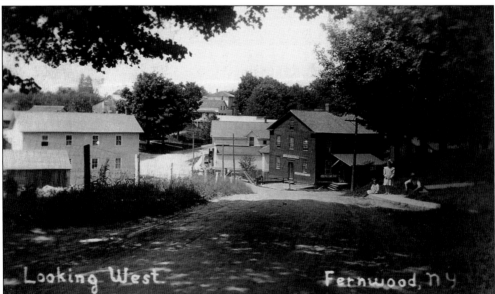

Looking West Fernwood, n.y.

This view from 1907 looks west as one heads into Fernwood. The Fernwood Mill is the large building on the left. The C.L. Goodsell & Son Feed Mill is the dark building on the right. Several Italianate, Greek Revival, and Gothic houses are located in the hamlet. The Mark McCullough house, built around 1870, is on the corner of Route 41A and North Fernwood Road. This was the former Church Wagon Shop. The basement had a forge, and the first floor was a wagon and carpenter shop.

Below the Bridge, Fernwood, N.Y.

The C.L. Goodsell & Son Feed Mill is the building on the left, the Fernwood Mill is across the street, and the Rich store and house is on the right. At one time, the community had three general stores, a blacksmith shop, a gristmill, a sawmill, a wagon and carriage shop, a tannery, a furniture factory, a post office, a railroad depot, and a two-room school.

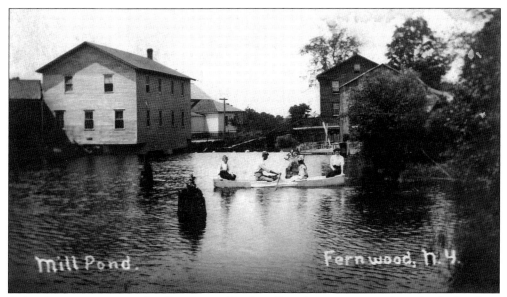

Mill Pond. Fernwood, N.Y.

A family goes rowing on the Grindstone Creek millpond, just upstream from the feed mill, in this 1911 view.

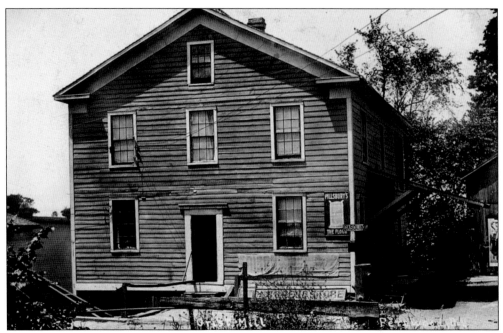

The C.L. Goodsell & Son Feed Mill was established in 1897. The three-story, rectangular, wood-framed mill, with a seamed tin roof, stands on the banks of Grindstone Creek, which provided the waterpower. It is seen here prior to 1920.

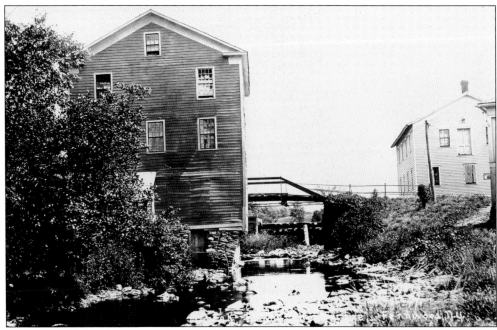

Charles Louis Goodsell came to Holmesville around 1885. The back of the C.L. Goodsell & Son Feed Mill sits next to Grindstone Creek. The dam still controls the flow of water in the creek.

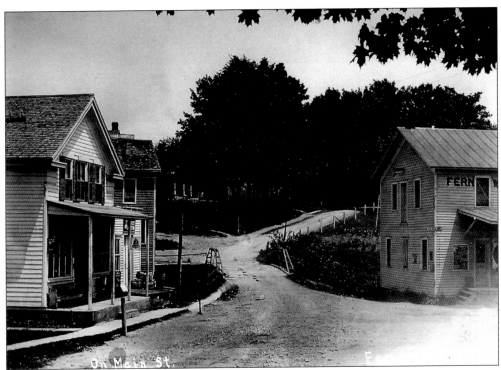

This view looks east on the main street in Fernwood towards the intersection of Route 41A and Valley Road. The Fernwood Mill is on the right, and the Rich store and house is on the left, across from the mill.

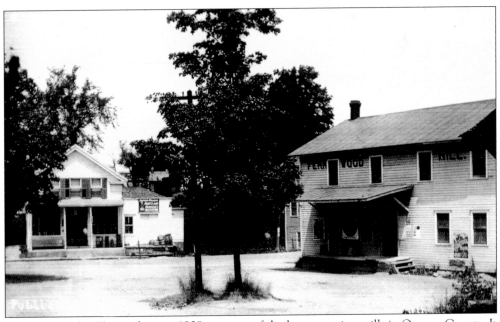

The Fernwood Mill, seen here in 1908, was one of the last operating mills in Oswego County. It has been a gristmill, a sawmill, and a cabinet shop. Jack and Joan Compo later converted it into a museum that operated for several years.

Isaac J. Rich's store was established about 1867 and was later owned by his son Fred B. Rich, who was born in the home part of the structure in November 1867. In 1869, the post office moved to the store, and Isaac Rich became the first postmaster of Holmesville. Fred bought the property in 1903 and continued the business until 1921. H.J. Webb of Pulaski ran it from 1923 to 1929. Sadie Reynolds Peters owned and operated the store from 1933 to 1945.

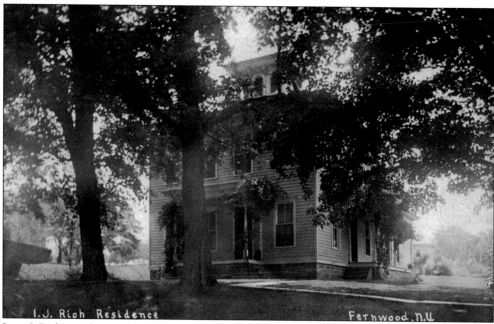

Isaac J. Rich's residence is pictured here in 1917. Rich was a Civil War veteran. In 1866, he bought out the share of a Mr. Stone in a general store built about 1858, and he became sole owner in 1868.

The Italianate-style home of Lora Church is located on Valley Road in Fernwood. Her husband, Charles, ran the Wagon Shop, a blacksmith business in the hamlet.

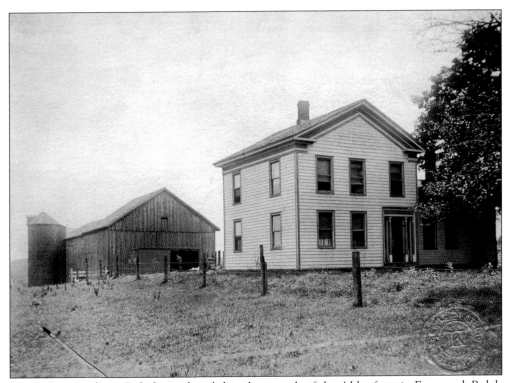

The Killam Studio in Pulaski produced this photograph of the Alder farm in Fernwood. Ralph P. Killam took over the Pulaski studio of H.R. Huested on Salina Street in July 1912. Killam operated a studio for 42 years.

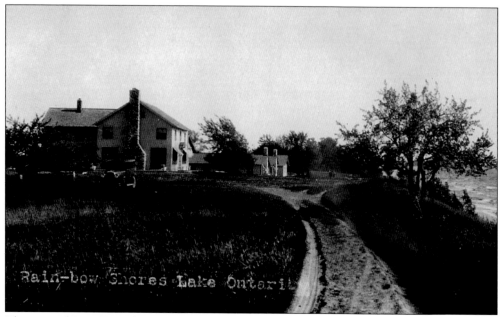

The original Levy Tryon homestead, on the shore of Lake Ontario, was remodeled as part of the Rainbow Shores Hotel between 1925 and 1926. Bathhouses and cottages date from the 1920s. Tryon wrote the poem "The Wreck of the Asp" about a schooner that broke up in a severe storm on the lake on October 12, 1820. Six local sailors and fishermen battled the high waves and rescued 2 of the 11 crew members and passengers.

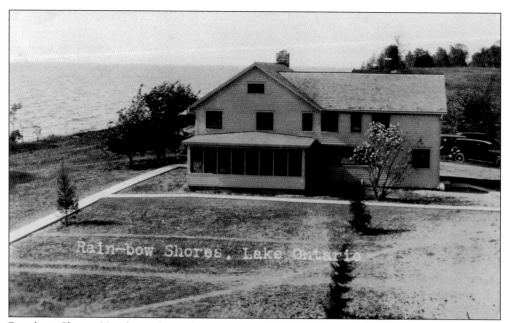

Rainbow Shores Hotel was formerly an exclusive country club in the late 1920s and 1930s. In Prohibition days, the shoreline was a favorite "landing spot" for bootleg liquor brought in from Canada.

Five

WE GATHER TOGETHER

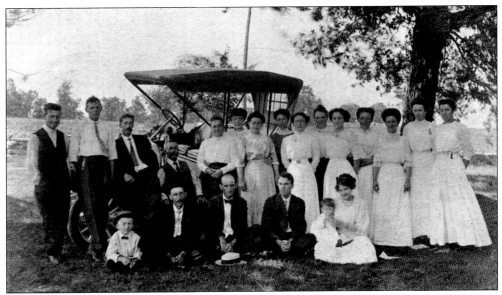

An unidentified group of the faithful gathers around for a photograph at a Beulah Park camp meeting in Richland in August 1911. (Courtesy of Lawrence Petry.)

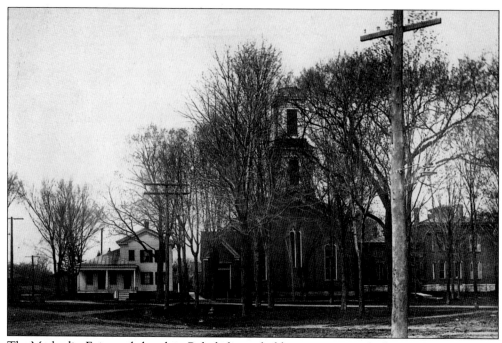

The Methodist Episcopal church in Pulaski began holding meetings at the home of John Ingersoll and the tavern of Pliny Jones as early as 1811. The first church was built at the corner of High and Salina Streets in 1832. This building on Hubble Street, with its three Florentine windows, was completed in 1860. It was remodeled and improved in 1888 by Pulaski builder David Bennett. The large wooden steeple was removed after significant windstorm damage in 1950. The parsonage is on the left. The church is now the Park United Methodist Church.

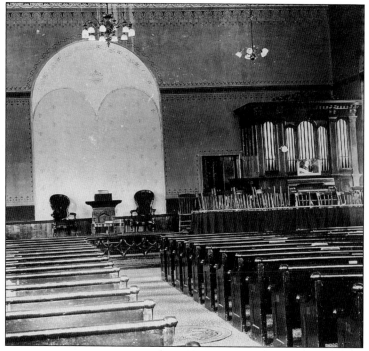

This view of the Methodist Episcopal church sanctuary was taken around 1906. The cost to build the church was about $10,000. It was designed to seat up to 1,000 people.

The Baptist Church and Society of Pulaski was organized at the courthouse in June 1828. The original, Federalist-style church building, seen here around 1885, was completed in December 1834 at the church's present site, Bridge and Broad Streets. It was built on the site of the old log schoolhouse that served the children on the north side of the Salmon River.

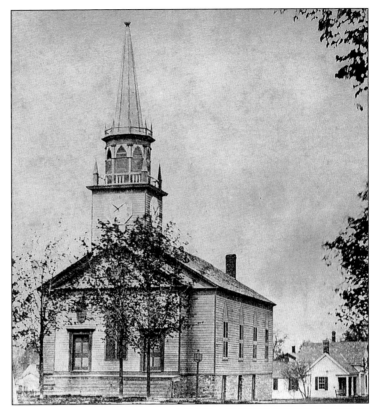

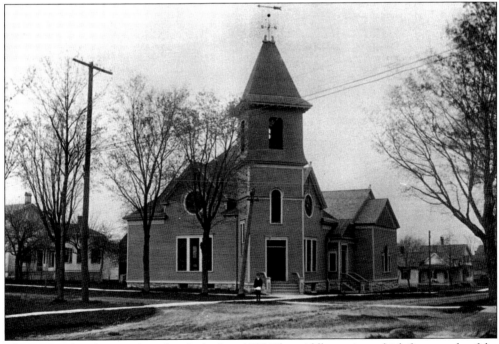

The Baptist church was enlarged and rebuilt in 1895. The middle portion, which faces north, of the present church, which generally faces east, is very similar in design to the old church of 1834.

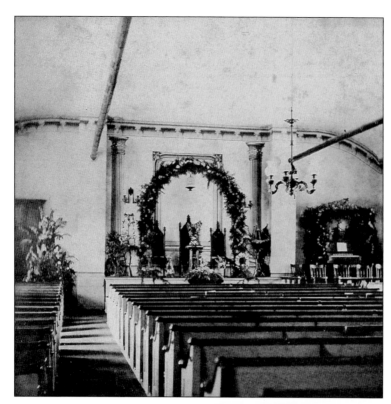

These two views show the interior of the Baptist church. The photograph at left is of the old church, dated June 1884. The photograph below was taken after the rebuilding in 1906.

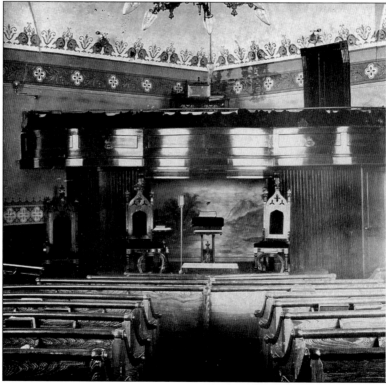

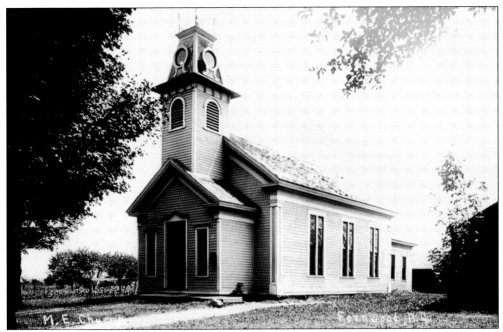

The Methodist Episcopal Church of South Richland (Fernwood) was organized in June 1840 and became a separate church body in 1851. This large Greek Revival church was built in 1858 at a cost of $800. This photograph was taken around 1908. The sanctuary of the church was remodeled in 1936. The church is located on Route 41A west.

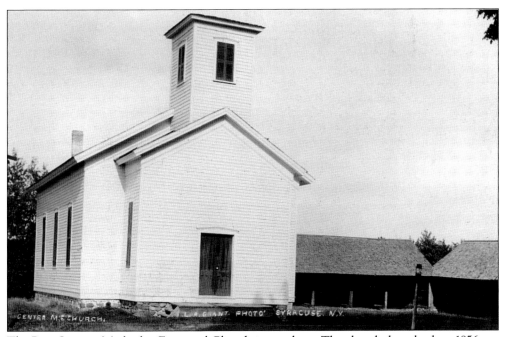

The Port Ontario Methodist Episcopal Church is seen here. The church dates back to 1856.

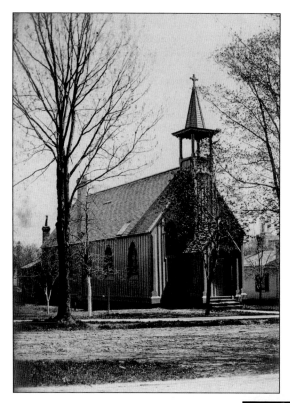

The St. James Protestant Episcopal Church, located on Lake Street in Pulaski, was organized at the courthouse on August 10, 1846. Richard Upjohn of New York City designed this Gothic Revival–style building. At one time, it had board-and-batten siding. The church building was consecrated on February 27, 1850. At that time, it was regarded as one of the prettiest church edifices in the diocese. William Pierrepont absorbed much of the $2,500 cost.

The Congregational church in Pulaski began at the home of Erastus Kellogg on January 22, 1811, and was incorporated in February of that year. The first pastor, Rev. Oliver Leavitt, arrived with the pioneering group from Pawlet, Vermont, and was installed on December 24, 1811. The first church was constructed in 1827 on the corner of Church and Bridge Streets. It was later used as a schoolhouse. The cornerstone of the new church, at Lake and Church Streets, was laid in 1865, and the building was dedicated on April 24, 1867.

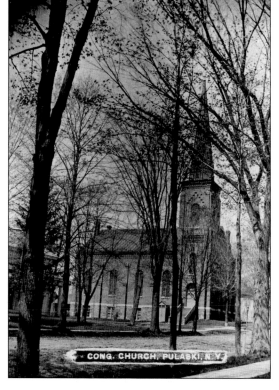

CONG. CHURCH, PULASKI, N.Y.

The Congregational church steeple is seen here being repaired in November 1905. John W., Frank, and Addison Bonney did the work on the steeple. It was also repaired in 1914 and 1918. After the severe windstorm of November 4, 1950, the spire was removed.

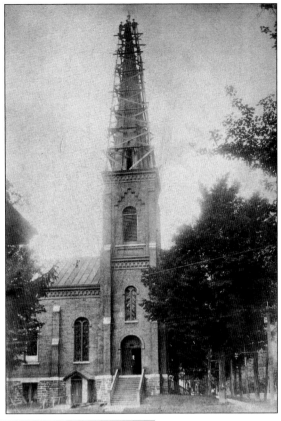

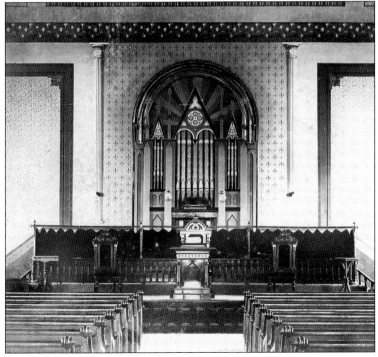

This is a view of the Congregational church sanctuary around 1906. The cost to build the church was about $16,000.

The Church of Seventh-Day Adventists of Pulaski was organized in November 1877. About 1900, several Adventist families erected a small brick church on Route 11 and Baldwig Road, south of Pulaski. A house of worship was built in 1903.

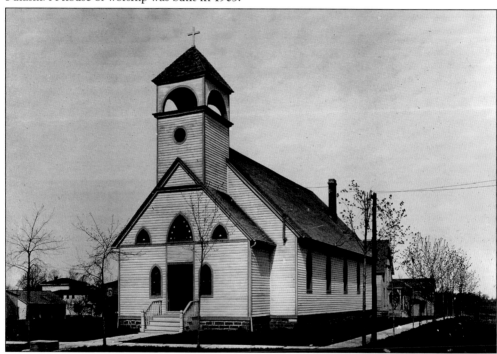

St. John the Evangelist Roman Catholic Church of Pulaski is located on the corner of Park and Niagara Streets. The cornerstone of the building was laid on August 28, 1888. The cost was about $2,500. The church was consecrated on January 16, 1898, and completely remodeled in 1960. The Willard Bonner residence on Park Street was purchased for the residence of Rev. Theodore Provost, the first pastor, in 1899.

The First Methodist Episcopal Church of Richland Station was organized on November 15, 1886, as a society, meeting at the schoolhouse in the village. This frame building was constructed in 1887 at a cost of about $1,500. The dedication took place on April 24, 1888. It is pictured here in 1914. (Courtesy of Lawrence Petry.)

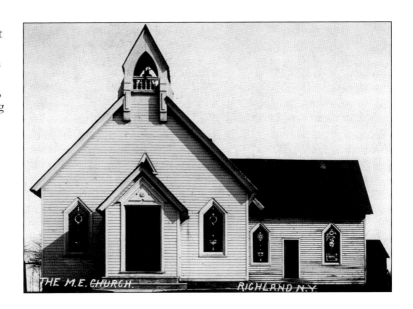

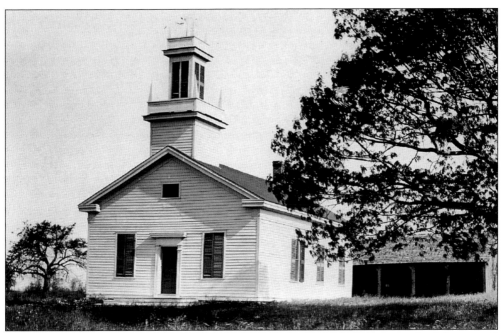

In Port Ontario, the Bethel Church was dedicated on January 9, 1850. It was built by a small group of area men inspired by George Bragdon, a Baptist, who lived on the Fort Oswego–Sacket's Harbor Road (now Route 3). The Bethel Church, pictured here around 1938, was used in the better weather of spring, summer, and fall as a meeting place for worshipers. Ministers of the Baptist and Congregational denominations came to hold services there. During summer months, the residents of the Lake Ontario camps and cottages would attend worship.

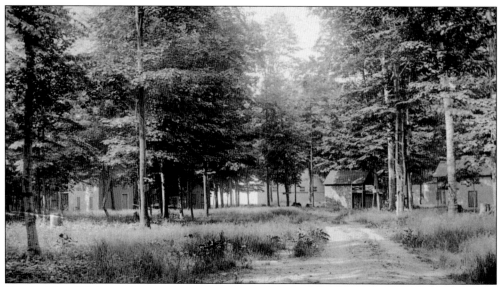

The Richland Holiness Camp is located on Route 48 in Richland. About 3,000 people attended the first camp meeting, held September 5–14, 1902, at Gilbert's Grove in Richland and sponsored by members of the Richland and Orwell Methodist churches. Those first campers came by horse or train. The organization was incorporated in 1904, and 32 acres of land were purchased. The campsite became known as Beulah Park. A large tabernacle was built in 1915. (Courtesy of Lawrence Petry.)

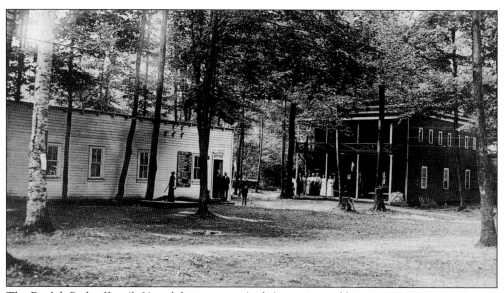

The Beulah Park office (left) and dining room (right) are pictured here in 1924. In 1926, George Beverley Shea, then a teenager and later associated as a singer with the Billy Graham Crusade, attended the camp meetings and earned his way by peeling potatoes in the kitchen. (Courtesy of Lawrence Petry.)

Six

EARLY SCHOOL DAYS

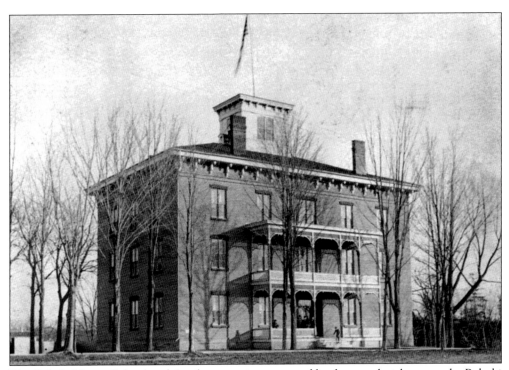

The Pulaski Union School and Academy was incorporated by the state legislature as the Pulaski Academy on June 4, 1853. In April 1854, a site on the bank of the Salmon River was purchased for $500. Ground was broken in May, and this three-story, brick building was dedicated on January 8, 1855. In 1892, the legislature chartered it as the Pulaski Union Free School.

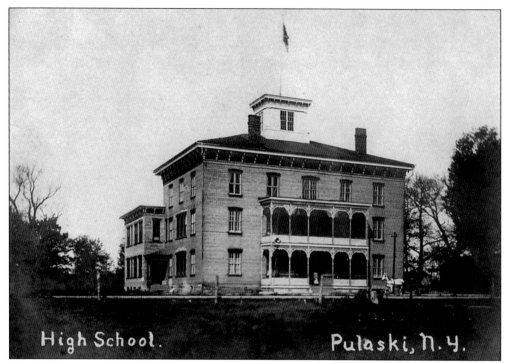

High School. Pulaski, N. Y.

This 1915 image of the Pulaski Academy shows the two-story, brick addition made to the rear in 1906. The expansion cost about $21,000. It had four grades on the first floor and two classrooms and a large study hall on the second floor.

The brick Academy Annex, at right, was built in 1926 and is all that remains today of the old Pulaski Academy. It was an annex for the junior high school and an auditorium with a stage and a balcony. The old academy grove is just south of the Salmon River, and a few of the oak, locust, and sycamore trees still stand there. The 1854 and 1906 portions of the academy were destroyed in a fire early on the morning of December 9, 1937. (Courtesy of Lawrence Petry.)

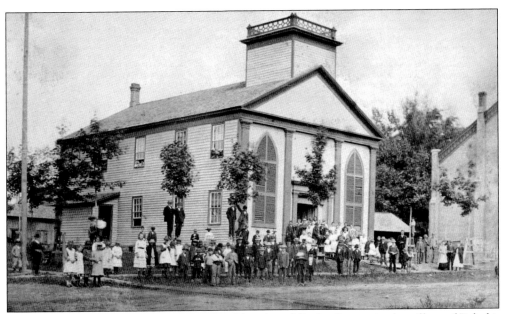

The old Congregational church, located at Church and Bridge Streets in the village of Pulaski, was used as a school in 1865 after a swap of properties with the board of education.

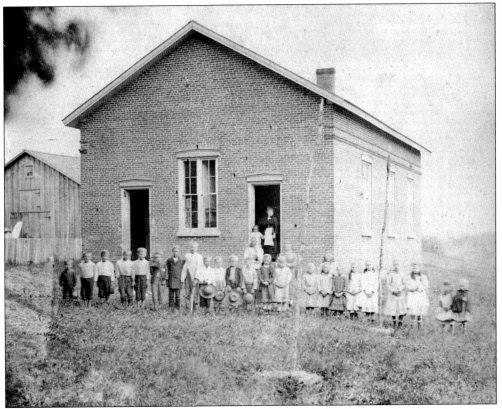

The Salina Street School is pictured here with an unidentified teacher and her class about 1877. The brick school was located on the south side of the Salmon River.

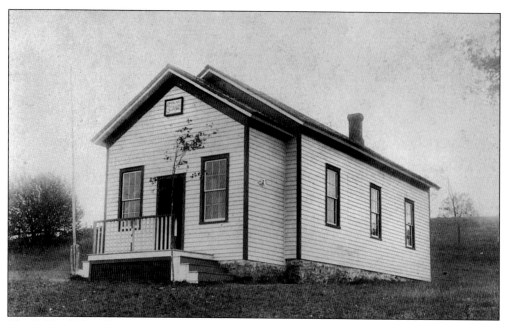

The Balsley School District No. 1 was established on August 7, 1897. It was located near Rainbow Shores Road on Route 3.

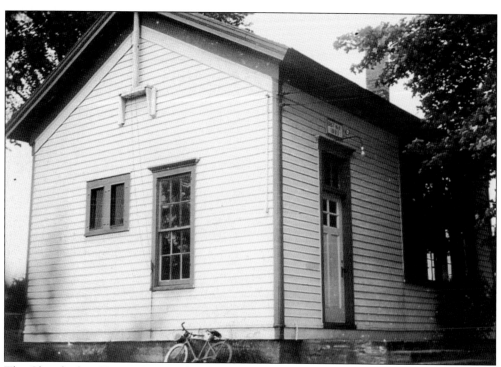

The Chamberlain District No. 9 schoolhouse is located on the Douglaston Manor property at Route 13 and Palmiter Road. The one-room schoolhouse with a brick chimney on the eastern end was built in 1885.

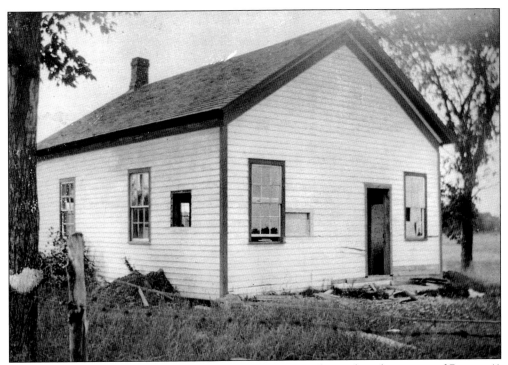

The schoolhouse for the Douglas, or Mowry, District was located at the corner of Routes 41 and 28 at Tyler's Corners in the southern part of the town of Richland. It was put up for sale in June 1940.

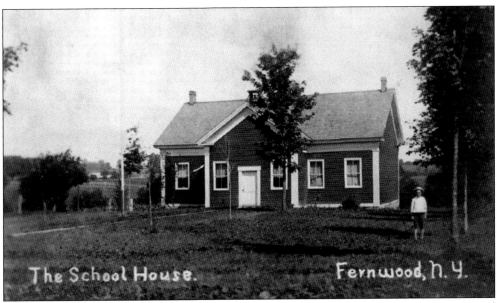

The Fernwood School District No. 17 was located on Valley Road in the hamlet of Fernwood (formerly Holmesville), in the southern part of the town of Richland. It is seen here in 1908. The Grange later took over the school in 1942.

The Hinman School District No. 2's first teacher was William M. Hinman. An 1850 map shows a schoolhouse located at North Street, a short distance north of Maltby's Corners, in the northern part of the town of Richland.

The schoolhouse for the Manwaring, or Daysville, School District No. 16 was put up for public sale in August 1938. It was located on Route 3 near the Pines Golf Course.

The Meacham School District No. 4 was established on April 26, 1861. The first schoolhouse, located on Canning Factory Road, was built for $295. The school was sold in the 1940s.

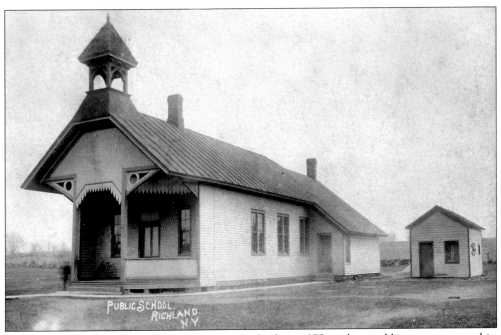

The Richland School District schoolhouse was built in 1875, with an addition constructed in 1888. The Richland Union Free School was incorporated on September 25, 1888. In 1939, all rural schools in the town of Richland were closed, and Richland School became the only feeder school for kindergarten through fourth grade. It was closed in 1970. (Courtesy of Dick Gorski.)

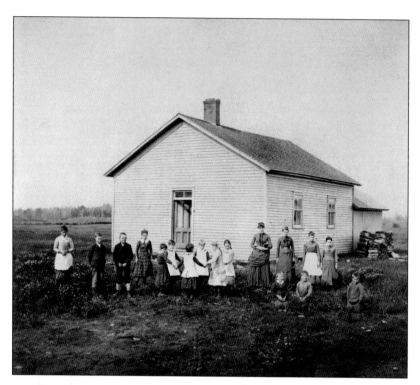

The Spring Brook District No. 13 school, pictured here in the 1890s, was located at the corner of Springbrook and Richland Roads, near the Mandigo farm.

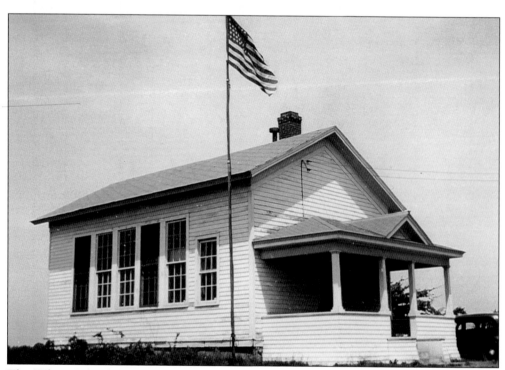

The White School District No. 11 schoolhouse was located at Tinker Tavern Road and Route 11 in the southern part of the town of Richland. It was put up for sale in June 1940.

Seven

A River Runs Through

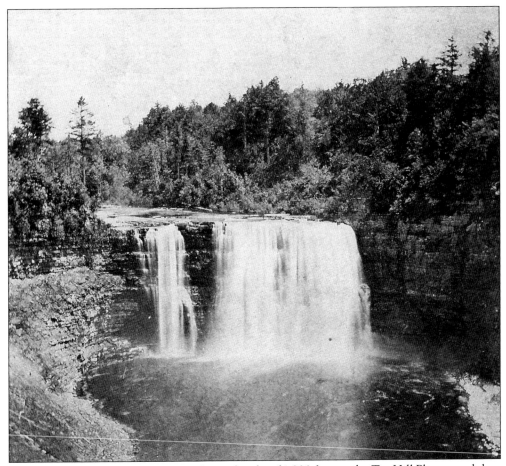

The Salmon River begins its journey from a height of 1,800 feet on the Tug Hill Plateau and then flows 44 miles westward to Lake Ontario. Brook and rainbow trout are plentiful in the upper reaches of the river. Pictured here in 1906 is the 110-foot-high Salmon River Falls, 12 miles east of Pulaski in Altmar, within the town of Albion.

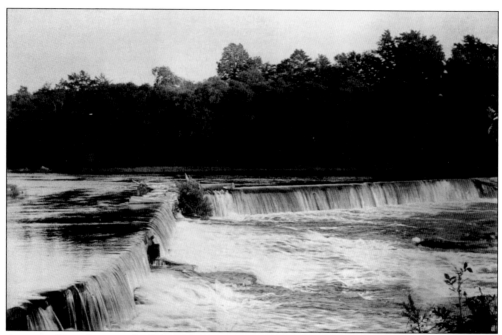

A series of four dams on the Salmon River were built within the village to control the river's flow, diverting it to raceways to provide power for the industries along its banks. The Frary Dam was located where Interstate 81 now crosses the river. It was used to divert water into Spring Brook to increase the speed of the waterwheel behind the Ontario Iron Works, and it then entered a stone passage and went under the Tollner plant. Spring Brook is a small stream flowing from several large springs, and it falls 150 feet over three miles.

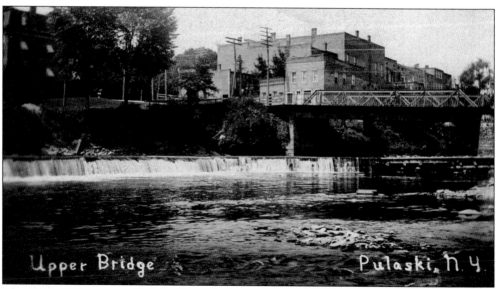

Upper Bridge Pulaski, N. Y.

The Upper Bridge, now called the Short Bridge, is pictured here, showing one of the dams along the river. This section of the river is popular today because of its salmon and steelhead trout pool. The Salmon River is now a big source of revenue to Pulaski and the surrounding towns because of the renewal of the salmon to the river's waters.

The river runs by factories and around islands in the village of Pulaski. The water powered such businesses as the Pulaski Book Board Mill, the Wilder Lumber Mill, the Mahaffy Brothers Woolen Mill, and the Salmon River Table Co.

This is a bird's-eye view looking east from the *Pulaski Democrat* offices. It shows the Long Dam, across the river, and the Tollner Box factory, at left, which used the waterpower of the river.

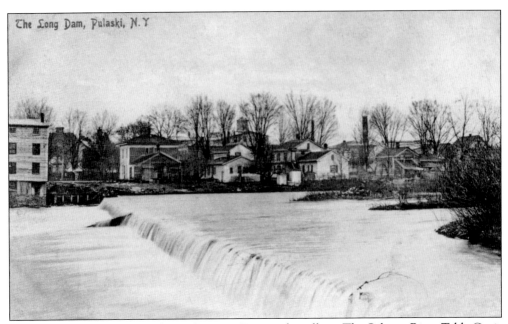

This ground view from 1909 shows the Long Dam in the village. The Salmon River Table Co. is at far left. (Courtesy of Lawrence Petry.)

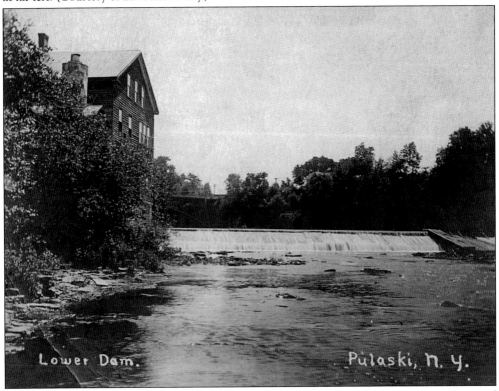

The Lower Dam, also known as the Box-Bennett Dam, is seen here looking upstream toward the Long Bridge. This dam supplied power for the Charmaphone Factory, Reed's paper mill, and other businesses along Factory Street (now Forest Drive).

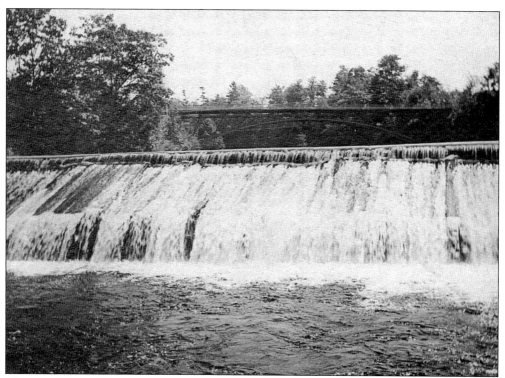

The Lower Dam is pictured here, with the Long Bridge in the background. The dam provided power for the Charmaphone Company, which made phonographs to compete with the Victrola. The Charmaphone building had previously housed David Bennett's sash and blind factory. This view of the dam is from the 1880s.

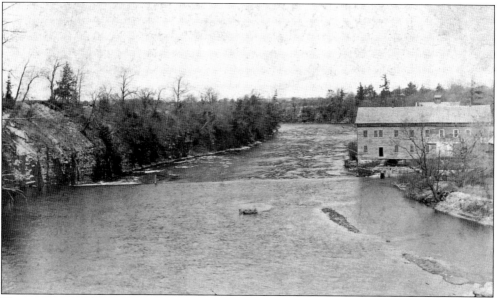

This view was taken from the Long Bridge, looking towards the dam and the building that housed the Charmaphone factory. A Charmaphone was a spring-cranked record player in a formal cabinet.

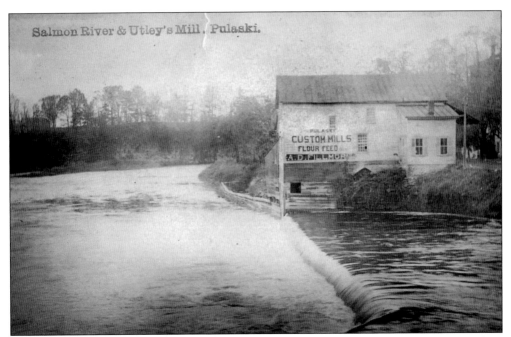

This view from the Short Bridge shows the A.D. Fillmore Custom Mills, also known as Utley's Feed Mill, on the west bank of the river. It was also powered by one of the dams built across the river.

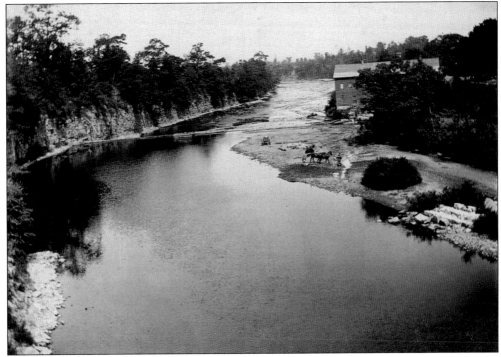

The Box-Bennett Dam is seen here from the Long Bridge. It provided waterpower for the Charmaphone Company factory, Charles Tollner's Pulaski Electric Light Company, and Reed's paper mill, all located on Factory Street (now Forest Drive).

Pictured here is the powerhouse at Bennetts
Bridge on the Salmon River, built in 1913.
Charles Tollner started the Pulaski Electric Light
Company in 1914. (Courtesy of Lawrence Petry.)

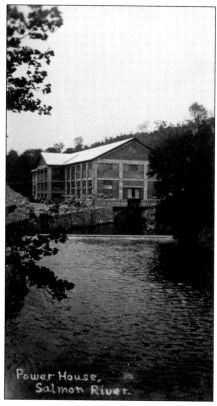

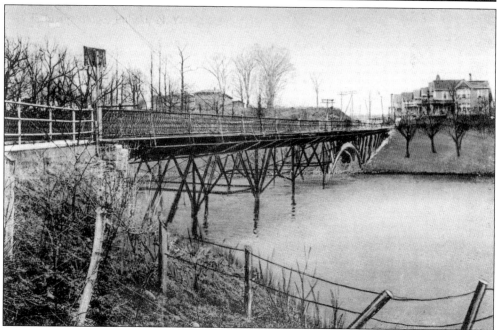

A contract to build the second Long Bridge was signed in July 1888 with the Wrought Iron Bridge
Company of Canton, Ohio. The bridge sections finally arrived on April 11, 1889. (Courtesy of
Lawrence Petry.)

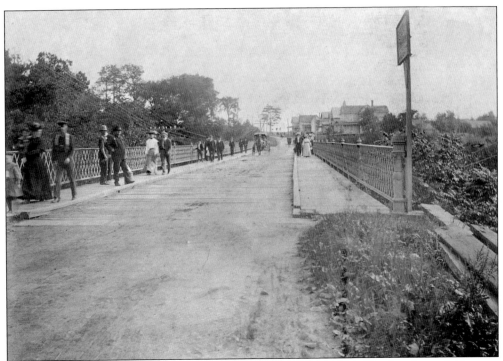

This view of the second Long Bridge is looking south around 1906. The first Long Bridge was used for the Syracuse Northern Railroad and built in 1871.

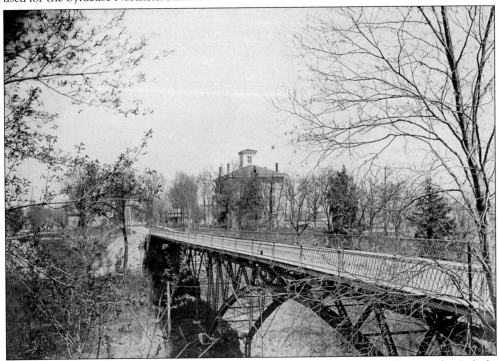

This view of the second Long Bridge is looking north towards Pulaski, showing the Pulaski Academy in the distance, in 1906.

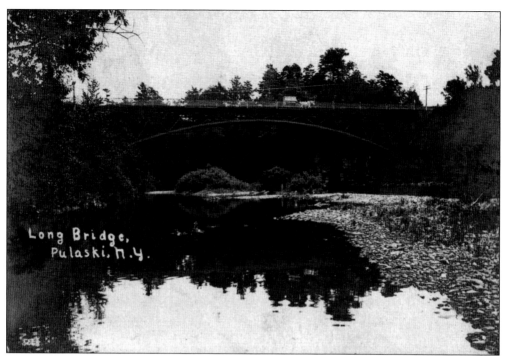

A horse and cart travel on the Long Bridge as it crosses the Salmon River. Built in 1889, this 216-foot span was the second bridge to be built near this location. West of the bridge is a downward section of the river known as "the Staircase," a mix of riffles and pockets good for fishing. (Courtesy of Lawrence Petry.)

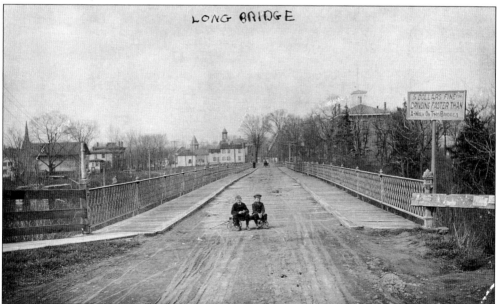

This view of the Long Bridge, looking towards Pulaski, was taken in 1906. On the far side of the bridge on the left side are, from left to right, the Congregational church steeple, the Baptist church steeple, and the courthouse cupola. The Pulaski Academy is visible on the right. The sign on the right says, "5 dollars fine for driveing faster than a walk on this bridge."

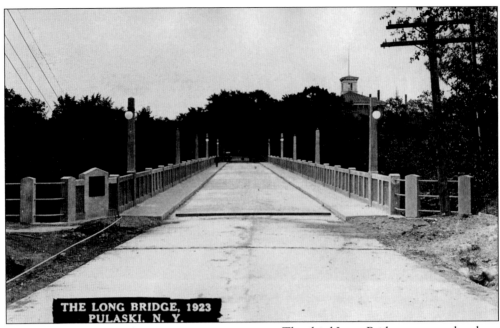

THE LONG BRIDGE, 1923
PULASKI, N. Y.

The third Long Bridge was completed across the Salmon River and opened for use on August 13, 1923. In the distance on the right is the top of Pulaski Academy. The bridge was used for more than 50 years before being torn down in August 1976. The fourth Long Bridge was opened in September 1978.

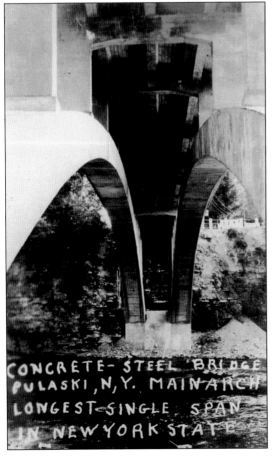

CONCRETE-STEEL BRIDGE
PULASKI, N.Y. MAIN ARCH
LONGEST SINGLE SPAN
IN NEW YORK STATE

The wrought-iron bridge built in 1888 was used as the base for the new concrete bridge. William Mueser of the Concrete-Steel Engineering Company of New York City designed the 1923 Long Bridge.

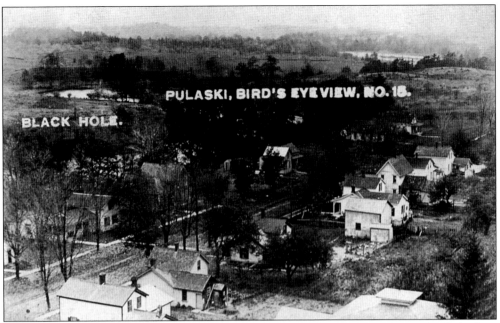

The "Black Hole," in the distance on the left, is noted in this bird's-eye view of Pulaski. It is considered one of the prime fishing areas in the river for bass and bullheads.

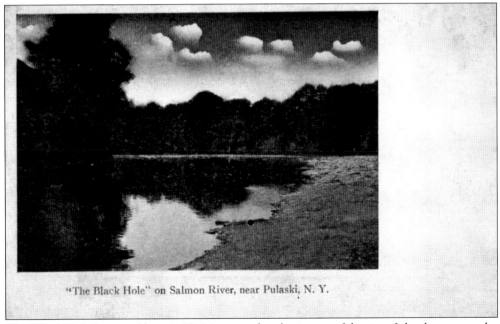

"The Black Hole" on Salmon River, near Pulaski, N. Y.

The "Black Hole," pictured here in 1914, is a very deep basin area of the river. It has been a popular spot for swimmers, picnickers, and fishermen. There was an old Indian trail along the southern side of the river, and artifacts have been found there. (Courtesy of Lawrence Petry.)

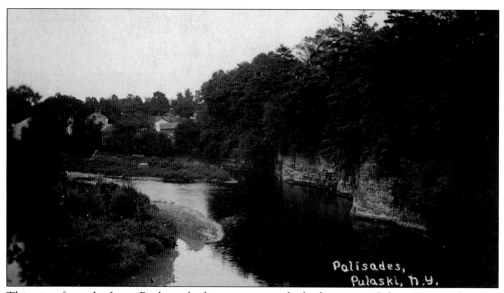

This view from the Long Bridge is looking east towards the houses on Salina Street. The river winds rapidly past the palisades in Pulaski on its journey west to Lake Ontario.

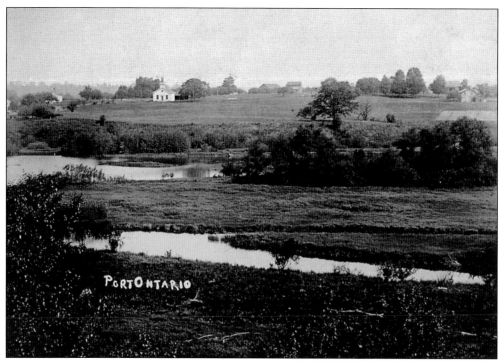

This is a view of the river as it meanders around Port Ontario. Bethel Church is the white building to the left of center.

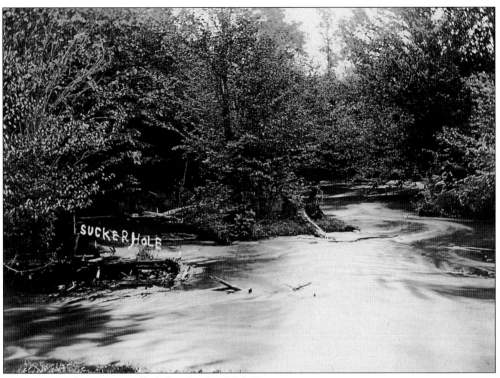

This spot in the river is called the "Sucker Hole."

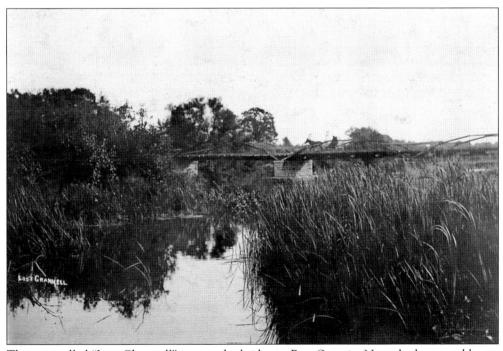

The area called "Lost Channell" is near the bridge in Port Ontario. Note the horse and buggy crossing the bridge in this image.

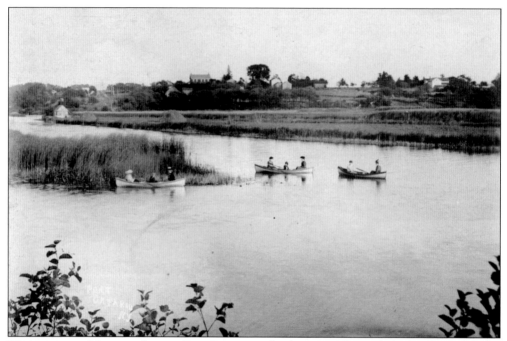

This is a view of the river showing Port Ontario in the distance. The Bethel Church is visible on the hill. (Courtesy of the Half-Shire Historical Society.)

As the Salmon River flows near Lake Ontario, it meanders around a number of channels and islands located in this lower portion of the river. This is a view of the north shore of Mary Ann Island, in the Port Ontario area, in 1907.

The north shore of Surveyor's Island is pictured here around 1907. A number of islands are clustered around the bridge at Port Ontario.

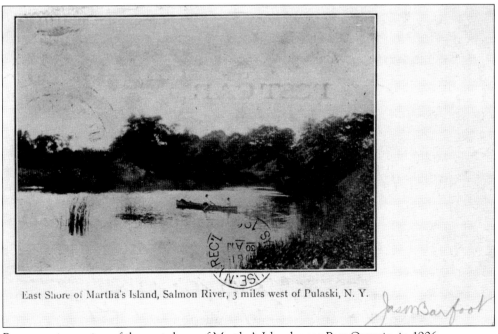

East Shore of Martha's Island, Salmon River, 3 miles west of Pulaski, N. Y.

Boaters enjoy a view of the east shore of Martha's Island, near Port Ontario, in 1906.

Mayme Babcock and J. Carrie relax as they enjoy rowing in the Salmon River.

This unidentified lady shows off her catch of fish in the 1920s. That must be a "captain's chair" she brought with her. The Salmon River was an important waterway for both Native Americans and settlers. The Iroquois called the river Heh-hah-wa-gahi, meaning "Where swim the sweet fish." Members of the Oneidas and Onondagas harvested the plentiful salmon in the fall.

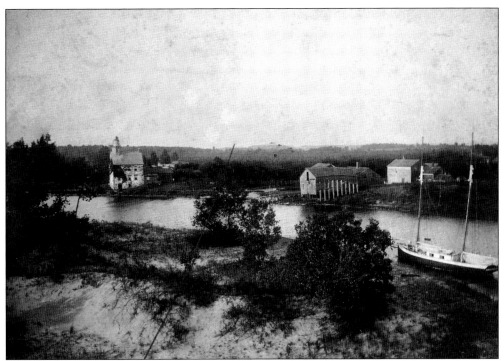

From 1838 to 1858, the Selkirk Lighthouse's beacon guided commercial lake vessels into Port Ontario to pick up lumber, cheese, and other local products. The large icehouse to the left of the ship and on the other side of the river was used to keep products cold before they were shipped.

Over the centuries, all types of boats have navigated the Salmon River, including log and birchbark canoes, French bateaus, longboats, flat-bottom boats, rowboats, sailboats, and all kinds of rafts.

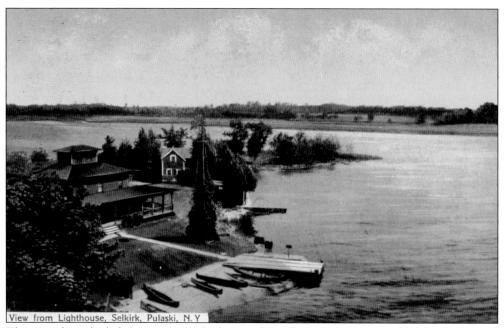

View from Lighthouse, Selkirk, Pulaski, N.Y

This view from the lighthouse in 1913 looks past the Tollner-Fitch cottage, with its vine-covered windmill, to the wide expanse of the river. The estuary is about a mile and a half long.

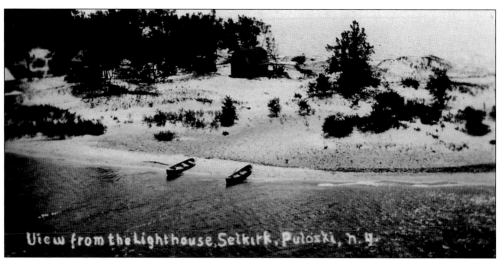

View from the Lighthouse, Selkirk, Pulaski, n. y.

The Salmon River is in the foreground and Lake Ontario is on the other side of the sand dune in this photograph from 1907. The dunes and beach areas are part of the Eastern Lake Ontario Dune and Wetlands Complex, a 17-mile stretch of land along the eastern shore of the lake.

The message on this postcard from 1905 says, "On the top of a sand dune is the Randall Cottage. Nice and cozy, all the people upstairs. A gas fire in the kitchen is burning, also gas for lighting. From the table where I am sitting I can see the picture on the card. The lake is rather rough looking."

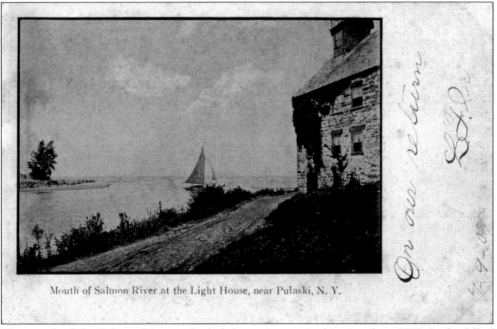

Mouth of Salmon River at the Light House, near Pulaski, N. Y.

The mouth of the Salmon River at the lighthouse is seen in this view from 1907. In the fall of 1615, the French explorer Samuel De Champlain and the Huron Indians first visited the site that eventually became the location of the Selkirk Lighthouse. Jesuit priest Fr. Simon LeMoyne came through on a mission to the Onondaga Indian Nation in August 1655.

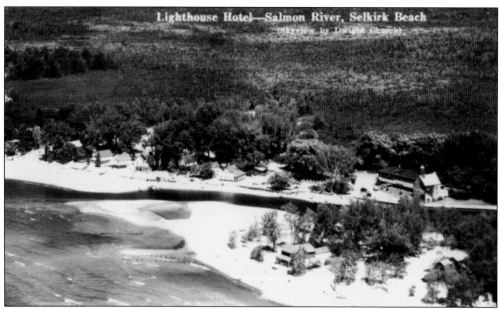

This sky view taken by Dwight Church shows the river as it passes in front of the Selkirk Lighthouse and Hotel (right) and cottages (left). The cottages are now part of the Brennan Beach area.

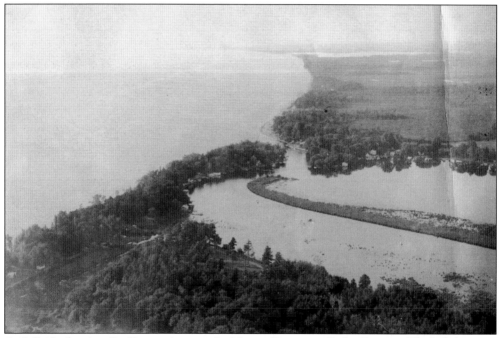

At Selkirk, the river finally empties into the Mexico Bay area of Lake Ontario. The lighthouse is just barely visible above the end of the hook. In the background is Deer Creek Marsh. In the 1650s, the French called the area La Famine, or "Hunger Bay," as a result of trials they faced there.

Eight

AND TRAIN TRACKS, TOO

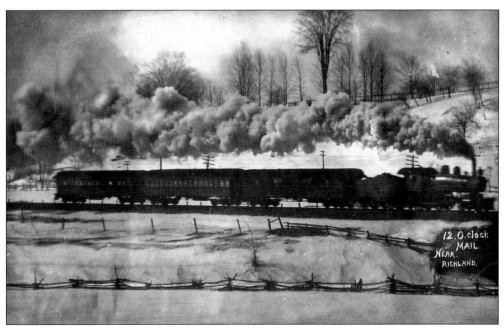

The "12:00 o'clock mail" train runs near Richland, which was the center of railroad activity in Oswego County from 1900 to 1945. It was the transfer point for passengers and freight and was served by lines originating in Oswego, Pulaski, Syracuse, Utica, the Thousand Islands, and Watertown. (Courtesy of Dick Gorski.)

The Rome & Oswego Railroad, completed in the fall of 1865, intersects the Rome, Watertown & Ogdensburg (RW&O) Railroad at the Richland junction. In 1875, the RW&O bought the Syracuse Northern at a foreclosure sale. The line stopped running between Pulaski and Lacona in 1877, and later, the tracks were pulled up between Pulaski and Sandy Creek. The RW&O system was leased to the New York Central, which was owned by the Vanderbilts, in March 1891, and it continued to operate freight and passenger trains through the 1920s. The Great Depression slowed business, and passenger service was eventually eliminated.

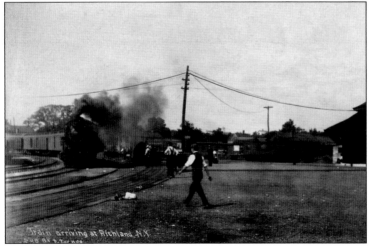

Steam locomotive engine No. 1997 is shown here arriving at Richland station (far right). The Richland terminal was the only one between Watertown, Syracuse, and Rome where the trains could be turned around. It was also the only coal and water stop between those cities. (Courtesy of Dick Gorski.)

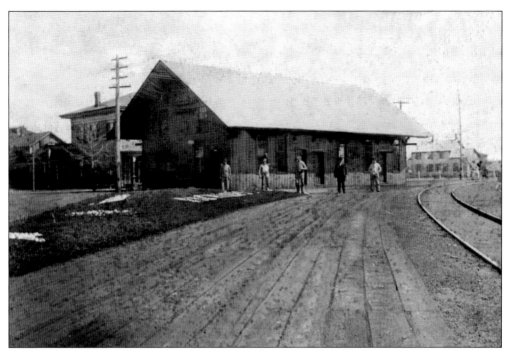

The old Richland depot, used in the 1860s, is pictured here. Most of the men from northern New York used this station as they headed off to serve in the Civil War. The Richland-to-Oswego line was built in 1863. (Courtesy of the Half-Shire Historical Society.)

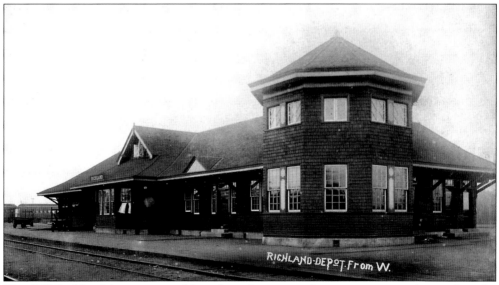

The 1903 Richland depot is viewed here from the west, with train cars on another track in the left background. There were 19 trains a day on six sets of tracks at the station. Inside the station, Frank and Albert Wright managed a restaurant that was well known throughout the New York Central system as an outstanding place to eat. Passenger service in Richland was discontinued in 1958. The Richland depot then became the Depot Corral Tavern, which burned down in March 1981. The large terminal at Richland is now a grassy field, and the rails going south of Richland to Rome are gone. (Courtesy of Dick Gorski.)

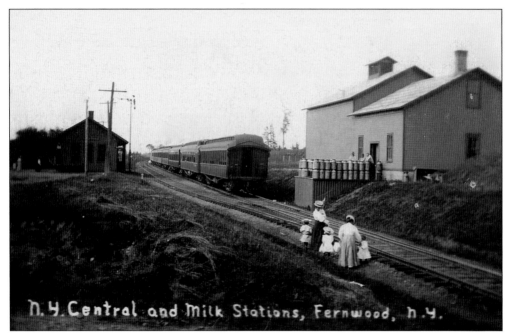

Here, the New York Central passes through the station at Fernwood in 1908. A milk station, with milk cans, is on the right, and the station is on the left. The Fernwood station has been relocated and added to the Baptist church in the hamlet.

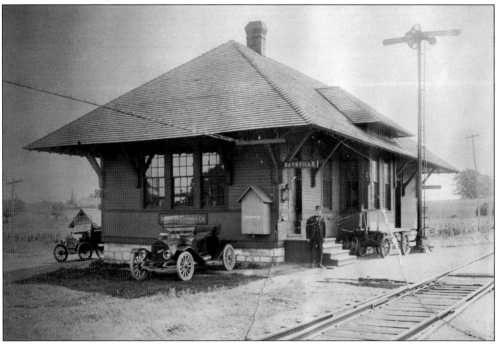

Daysville was a station on the Rome & Oswego Railroad starting in 1863. The original station was destroyed by fire in June 1901, and a new depot was built in 1902. The New York Central discontinued the station in August 1938. After the trains stopped running, the Daysville depot was moved to the north side of Lake Road (Route 5), near the Selkirk Lighthouse.

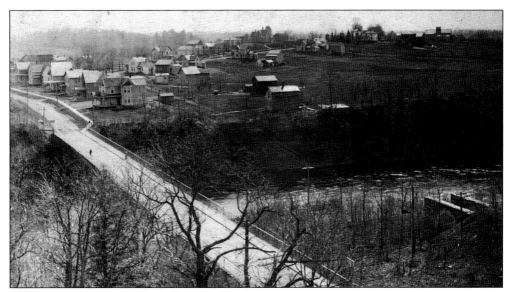

The Syracuse Northern Railroad built the first Long Bridge in 1871 to connect Pulaski to Syracuse by direct rail. As steam locomotives crossed the Salmon River, the railroad ran north along Broad Street and near the west side of the county courthouse before continuing north out of town to Sandy Creek. The masonry arches of that first bridge abutment can be seen here in the lower right. The railroad bridge was abandoned along with the train line to Sandy Creek in 1878. Pedestrians and wagons used the abandoned bridge as a route between the downtown business district and the train depot on Port Street. In 1885, Charles Tollner, owner of the Tollner Box Factory, leased the bridge and repaired it at a cost of $300. By June 1888, the bridge was dismantled because the timbers were badly decayed.

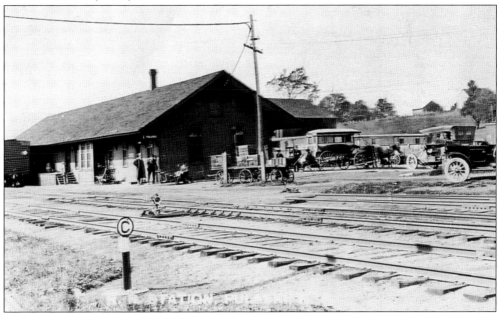

The Pulaski railroad depot, seen here in 1910, served patrons of the railroad lines passing through Pulaski to the east and west. Three modes of transportation converge in this image, as a horse cab driver and early automobiles await the coming train. (Courtesy of Andy Gibbs.)

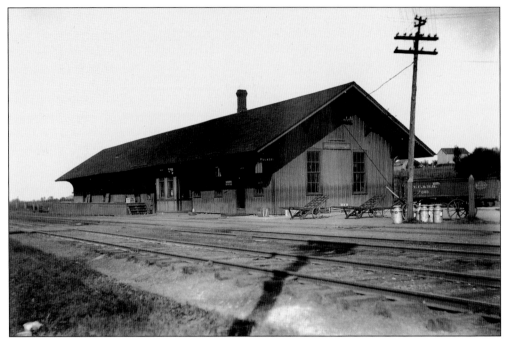

The old Pulaski station was located at Salina and Port Streets. Here, milk cans await pickup and a New York Central & Hudson River train car sits in the background. The present railroad company, Conrail, serves the Syracuse-to-Massena area with only freight trains. At one time, the Rome, Watertown & Ogdensburg and the New York Central carried patrons to the Richland junction.

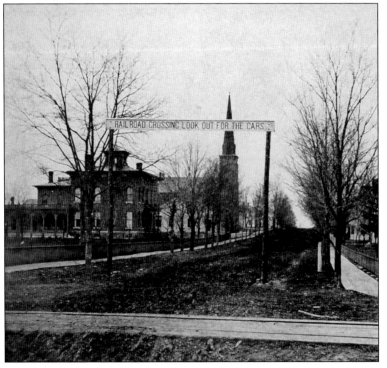

This is an early version of a railroad crossing sign, with the familiar saying, "Rail Road Crossing Look Out For The Cars." This view from the 1870s looks north up Bridge Street as the tracks cross on Broad Street, with the Louis J. Clark house on the left and the Congregational church in the background.

Nine

TIME TO CELEBRATE

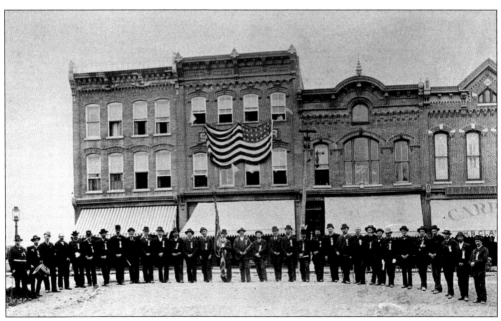

Members of the Pulaski Grand Army of the Republic (GAR) J.B. Butler Post No. 111 pose here at the east end of Lake Street on May 30, 1891. These men served in the Union army during the Civil War. The post was named for Lt. J. Bradley Butler, who died at Port Hudson, Louisiana, on June 21, 1863. Before the war, Butler worked with Charles Cross doing surveying and mapping in the land office. Delano Gilson Moody was the last remaining Civil War veteran from Pulaski. He died on Abraham Lincoln's birthday, February 12, 1938, at age 96.

These ladies enjoy some time in the canoes by the Tollner-Fitch cottage at Selkirk. Harriet Fitch purchased the cottage in 1903 and turned it into a summer boardinghouse. She was well known in the development of Selkirk Beach into a summer resort.

These men display their good catch of fish for the day. Among the fish available along the Salmon River were salmon, trout, black bass, pickerel, pike, and panfish. (Courtesy of Andy Gibbs.)

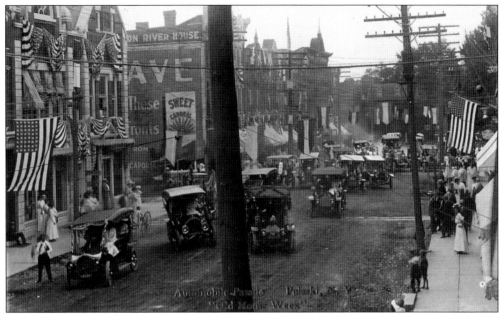

These cars are decked out for the auto parade during Old Home Week celebrations in 1911. The view looks south on Jefferson Street. The Pulaski National Bank is on the left.

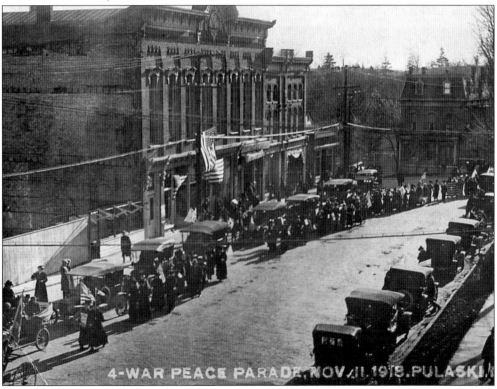

The 4-War Peace parade marches up North Jefferson Street on Armistice Day, November 11, 1918, celebrating the end of World War I. The Betts Opera House is on the left, and the J.L. Hutchens House is at the end of the street.

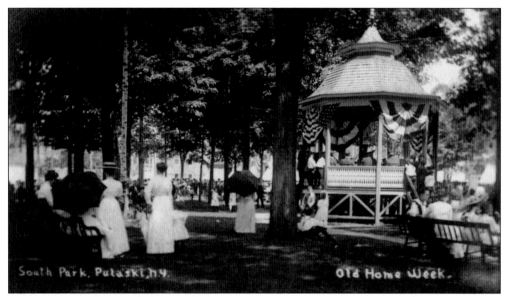

A Victorian gazebo was built in South Park around the beginning of the 19th century and was used for band concerts in the summer. Beginning in 1936, Firemen's Field Days were held in the park. (Courtesy of Lawrence Petry.)

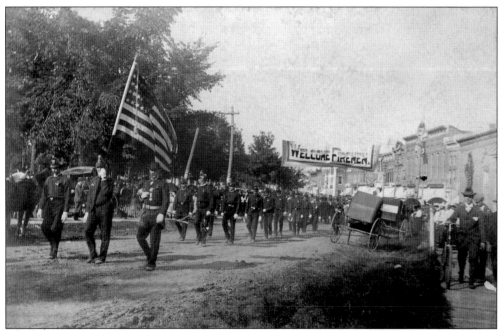

One of the many popular parades from around 1900 is pictured here as it proceeds south, going past South Park (left) on Jefferson Street in Pulaski. Firemen's parades were held on Memorial Day and on the Fourth of July.

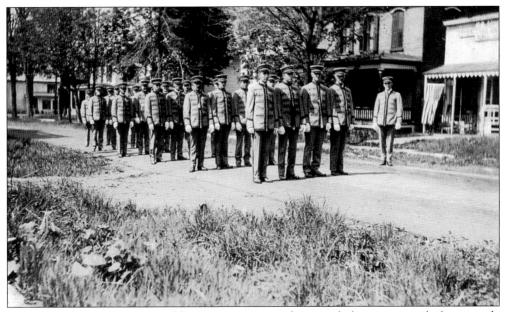

These firemen from the Ringgold Fire Company stand in march formation, ready for a parade to begin around 1890.

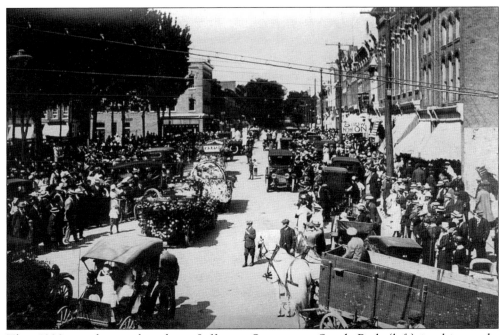

This 1930 parade marches down Jefferson Street past South Park (left) in this north-facing view.

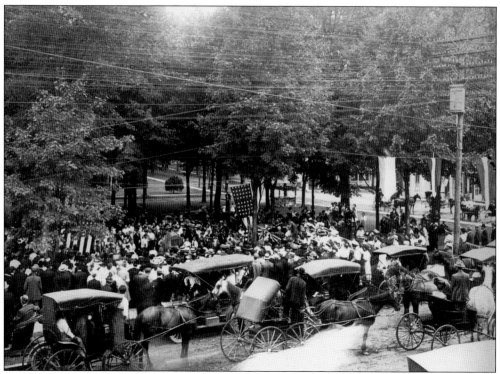

A crowd gathers at the Memorial Boulder in Pulaski's South Park at its dedication on August 10, 1910. William Peach brought the stone to the park with his horse and wagon. The boulder is visible in the crowd, just above the second horse carriage from the left.

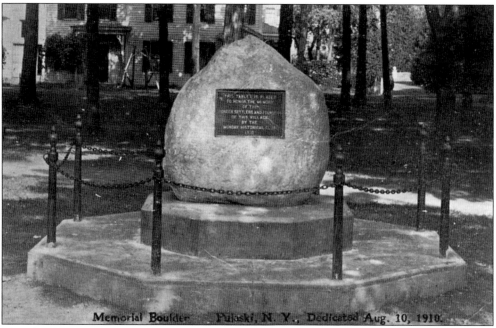

Memorial Boulder Pulaski, N. Y., Dedicated Aug. 10, 1910.

The plaque on the Memorial Boulder reads, "This tablet is placed to honor the memory of the pioneer settlers and founders of this village by the Monday Historical Club 1910."

BIBLIOGRAPHY

Churchill, John C., ed. *1895 Landmarks of Oswego County, New York*. Syracuse, NY: D. Mason & Company, 1895.

Half-Shire Historical Society. Images of America: *Northern Oswego County*. Charleston, SC: Arcadia Publishing, 2003.

Hungerford, Edward. *The Story of the Rome, Watertown and Ogdensburg Railroad*. New York: Robert M. McBride & Company, 1922.

Johnson, Chrisfield. *History of Oswego County, N.Y., 1789–1877*. Philadelphia, PA: Everett & Ferriss, 1878.

Kustich, Rick. *River Journal—Salmon River*. Portland, OR: Frank Amato Publications, Inc., 1995.

Marston, Hope Irvin. *Salmon River Odyssey: The Town of Richland and Its Hamlets*. Syracuse, NY: Syracuse University Press, 2002.

Muller, Robert G. Images of America: *New York State Lighthouses*. Charleston, SC: Arcadia Publishing, 2005.

Parker, Mary. *Historic Pulaski—An Architectural History of Pulaski, New York*. Pulaski, NY: Pulaski Historical Society, 1994.

Pulaski Historical Society. *Historical Souvenir of Pulaski, N.Y. and Vicinity*. Pulaski, NY: Pulaski Historical Society, 1982.

Rossman, Terry. *Pulaski—Oswego County's Factory Town*. Pulaski, NY: Pulaski Historical Society.

Russell, Harold. *History of the R.W.&O.* 2009. www.rworr.net/history/russell-history.

Snow, Vernon F. *JBS—A Biography of John Ben Snow*. Utica, NY: North Country Books, Inc., 1974, 1992.

Snyder, Charles M. *Oswego: From Buckskin to Bustles*. Port Washington, NY: Ira J. Friedman, Inc., 1968.

DISCOVER THOUSANDS OF LOCAL HISTORY BOOKS FEATURING MILLIONS OF VINTAGE IMAGES

Arcadia Publishing, the leading local history publisher in the United States, is committed to making history accessible and meaningful through publishing books that celebrate and preserve the heritage of America's people and places.

Find more books like this at
www.arcadiapublishing.com

Search for your hometown history, your old stomping grounds, and even your favorite sports team.

Consistent with our mission to preserve history on a local level, this book was printed in South Carolina on American-made paper and manufactured entirely in the United States. Products carrying the accredited Forest Stewardship Council (FSC) label are printed on 100 percent FSC-certified paper.

MADE IN THE USA